KODAK PROFESSIONAL
Black-and-White Films

KODAK PROFESSIONAL Black-and-White Films

Front cover photo: Scott Bixler

Second Printing, 2000
Revised Edition, 1998 ©Eastman Kodak Company, 1990
All rights reserved. Reproduction in whole or in part is not permitted
without prior written permission of the publisher.

Publication F-5
Cat. No. E152 8298
Library of Congress Catalog Card Number 97-65808
ISBN 0-87985-796-X
Printed in the United States of America

Kodak
LICENSED PRODUCT

*The Kodak materials described in this book are available from
those dealers normally supplying Kodak products. Other materials
may be used, but equivalent results may not be obtained.*

KODAK Books are published under
license from Eastman Kodak Company by
 Silver Pixel Press®
 A Tiffen® Company
 21 Jet View Drive
 Rochester, NY 14624 USA
 Fax: (716) 328-5078
 www.saundersphoto.com

© Jock McDonald, 1988

KODAK T-MAX 100 Professional Film is an excellent choice for photographing detailed subjects in the studio.

CONTENTS

Portrait made on KODAK TRI-X Pan Professional Film.

Film is one of the professional photographer's basic tools. Kodak black-and-white films are designed with a wide variety of characteristics for many different applications. This book will help you select and use the Kodak black-and-white films that best meet your needs.

The following chapters also review the requirements and procedures for making high-quality negatives *consistently*—the mark of the professional. Control of film exposure and processing is fundamental. Exposure and processing affect tone reproduction, graininess, contrast, and shadow and highlight detail, and ultimately determine print quality.

If you follow the procedures in this book, you can be sure that your negatives will be able to yield prints that appear vivid and lifelike—prints that snap and make your subjects come alive. Although it is the print that signals your success, the negative lays the groundwork.

Finding the right film for a particular application may not require special skills, but it does require a thorough knowledge of the many films that are available—or a good reference book like this one. Does the task at hand require a high-contrast film? A reversal film? Would a panchromatic film with extended red sensitivity have produced better

results when you photographed that new office building? What will your next assignment require? This book gives you a comprehensive description of Kodak black-and-white films and their characteristics so that you can always choose the best film for the job.

Sections on contrast index, photographic and physical properties of film, storage, handling, and processing round out the text of the book. Data Sheets for Kodak films, grouped at the back of the book, include information on applications, sizes, speed, granularity, resolving power, and processing, as well as characteristic curves.

Negative Quality

Most of the films described in this book are designed primarily for producing black-and-white negatives. Photographers often ask "What constitutes a *good* black-and-white negative?" Think of negative quality in two ways: (1) the factors that determine the quality of a single negative and (2) the factors you must control to produce consistent quality in *all* your negatives.

Making prints from relatively uniform negatives is easier and more economical than printing negatives that vary considerably in density and contrast. Although you cannot get identical density and contrast in negatives of different subjects exposed under different lighting conditions, you can produce negatives with more consistent density and contrast if you determine exposure carefully and control development. In turn, these negatives will yield more prints of good quality.

To become familiar with the materials, start with only a few films and developers. The data in this book will help you develop the techniques required to produce negatives that will print consistently with your equipment on the paper you choose.

Graphic Representation of Typical Photographic Tone Reproduction

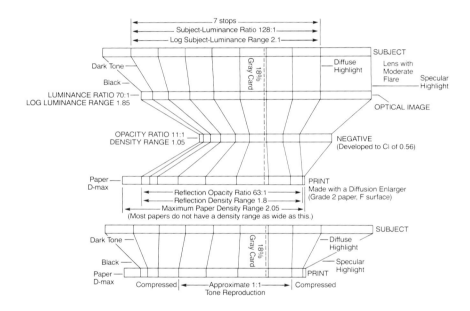

This diagram shows how the tones are expanded or compressed in the tone-reproduction process. The lower part of the diagram shows a direct comparison of the subject with the print.

CHARACTERISTICS OF A HIGH-QUALITY NEGATIVE

A high-quality negative is one that will yield a high-quality print when you print it with your enlarger or contact printer. This definition requires more explanation:

- The shadow densities of the negative—determined primarily by exposure—should be great enough (0.10 to 0.15 above the base-plus-fog density) to reproduce as tones just lighter than black in the print.

- The density range of the negative—determined by development—should match the range of the paper when you expose it with your printing equipment.

TONE REPRODUCTION

Tone reproduction is one of the most important factors in technical print quality. The black-and-white photographic process converts the neutral and colored tones of a subject into whites, grays, and blacks in a print. How well these tones represent the subject is a prime measure of photographic quality.

The brightness range (or luminance ratio) of a typical outdoor subject frontlighted at a 45-degree angle to the camera-subject axis is approximately 160:1. This range represents a difference of approximately 7 stops between the lightest diffuse highlights and the darkest shadows that will print just lighter than black. The 7-stop range is separated by only about 6½ stops in the camera image at the film plane. (This compression is caused by a modest 2-percent flare factor in a high-quality camera lens.)

The density range of a typical negative will be about 0.80 to 1.25, depending on the type of enlarger that will be used to print it. The density range of a black-and-white print is typically 1.5 to 2.0, depending on the paper. Therefore, the tonal range is considerably compressed from the subject to the negative, and then it is expanded when it is printed.

Because the original subject has a brightness range of 160:1 and photographic papers have only a 60:1 brightness range (or reflectance ratio), overall compression in the tonal range occurs from the subject to the print. However, the typical photographic black-and-white process does not compress and expand all parts of the brightness range and tonal scale evenly. The tones that print just lighter than black are compressed considerably. Moderately dark tones are compressed somewhat. *The midtones are usually reproduced with no compression at all*—this means that the brightness ratio between adjacent tones in the middle of the tonal scale is nearly the same in the print as it is in the subject. Highlight tones are compressed, but not as much as shadow tones. The shadow region is compressed more in the negative because it falls

on the toe of the characteristic curve, where the film's response to light falls off. This type of tone reproduction, with relative values, is shown in the diagram on page 6.

A good negative is one that will yield a high-quality print (with your printing equipment) in which the tones are reproduced as just described.

JUDGING NEGATIVE QUALITY VISUALLY

Not all photographers have equipment to measure negative densities, but experienced photographers can usually determine whether or not a negative has the quality required for a particular application by looking at it. The following method will help photographers with less experience to choose the best negative from an exposure series.

Place each negative, emulsion side down, on a sheet of good-quality black-and-white printed material. If you will print the negative with a diffusion enlarger, you should be just

able to read the larger type (see illustration) through the diffuse highlights of the negative. The deepest shadows should be clear and the detailed shadows should show varying light densities. A portrait negative that passes this test should print well on a normal-contrast paper with a diffusion enlarger.

Negative for printing with a diffusion enlarger

Negative for printing with a condenser enlarger

Martin Czamanske

To judge negative density and contrast, place each negative—emulsion side down—on a sheet of good-quality black-and-white printed material. Negatives intended for printing with diffusion enlargers should be somewhat more dense and have higher contrast than those intended for printing with condenser enlargers. When you look at the large type through the diffuse highlights of negatives for printing with a diffusion enlarger, you should be just able to read it. When you look through the diffuse highlights of negatives made for printing with condenser enlargers, you should be able to read the type easily. The shadow detail in the negatives should be similar, but the shadows in negatives for diffusion enlargers should have slightly more contrast than those in negatives for condenser enlargers.

A negative that you will print with a condenser enlarger should have similar characteristics in the shadows, but the diffuse highlights should be less dense so that you can easily read the type through these areas.

Here are the other visual characteristics of a good-quality negative:

- Every part of the negative that is intended to be sharp should look sharp when you view the negative through a magnifying glass.
- The overall density should allow a reasonably short exposure time.
- The density range of the negative should print on grade 2 (normal-contrast) paper with your printing equipment to produce good highlight and shadow detail.
- The deepest shadows should be clear in the negative. The midtones should have adequate detail.
- The diffuse highlights should show gradation and have noticeably less density than the specular highlights.
- The printed image should be no grainier than is normal for a particular film.
- The negative should be free of scratches, static marks, scum, water spots or marks, pinholes (caused by dust or improper development), and dried-on dust.
- The negative should not show mottle or uneven densities caused by improper agitation or a short development time.

MEASURING NEGATIVE QUALITY

A precise method of judging the printing quality of a negative is to measure certain densities with a densitometer. You can use these measurements to—

- Evaluate film exposure. Measure the density of a shadow area that should print just lighter than black. Its density should be 0.10 to 0.15 above the base-plus-fog density of the film (see the explanation of base-plus-fog density on page 9).
- Evaluate film development. Measure a diffuse-highlight area that should print just darker than white. Subtract the density of the shadow area from the density of the diffuse highlight to determine the *density difference.* If a subject has a normal brightness ratio of 160:1, the density difference (negative density range) should be about 1.05 for negatives that you will print with a diffusion enlarger or 0.80 for negatives that you will print with a condenser enlarger.

For example:

	Diffusion Enlarger	Condenser Enlarger
Density of lightest diffuse density	1.20	1.00
Density of detailed shadow	− 0.15	− 0.20
Density range	1.05	0.80

The aim density ranges of 1.05 for diffusion enlargers and 0.80 for condenser enlargers are average figures that were derived from tests made with many enlargers. Negatives with these density ranges should yield proper print contrast on a grade 2 or normal-contrast paper. If your print contrast is consistently too low, increase the film development time to produce negatives with a higher density range that provides the contrast you want on grade 2 paper with your enlarger. If your print contrast is consistently too high, decrease the development time to obtain negatives with a lower density range that provides the contrast you want.

Note: The density ranges of many negatives will be higher or lower than this aim because subject brightness ranges vary. Graded and selective-contrast papers accommodate these differences.

Sensitometry

The procedure of determining how photographic materials respond to exposure and processing is called *sensitometry.* Most of the information given in the Data Sheets (pages DS-2 to DS-26) is given in sensitometric terms. Although you do not need to know everything about sensitometry to produce high-quality black-and-white photographs, a basic understanding will help you control your techniques to obtain consistently good results.

THE CHARACTERISTIC CURVE

The response of a photographic emulsion to exposure and development is most clearly expressed by a graph called the *characteristic curve.*

To obtain the characteristic curve of a film, a section of the film is carefully exposed through a step tablet, such as the one shown at the right, in an instrument called a sensitometer. The step tablet produces a series of exposure steps on the film. Each step differs from the preceding step by a constant factor, such as 2 (one camera stop) or the square root of 2 (1.41)—one-half stop. The exposed film sample is developed under very carefully controlled conditions to yield a test film with a series of steps that differ in *density.*

Density * is a measurement of the light-stopping characteristics of an area in a photographic image. It depends largely on the amount of

* *Transmittance* is the ratio, in decimal form, of transmitted light divided by incident light. When half the incident light passes through a piece of film, the transmittance of the film is 0.5. *Opacity* is the reciprocal of the transmittance (1/0.5 = 2). *Density* is the logarithm of the opacity ($Log_{10}2 = 0.301$). A film density of 0.3 transmits 50 percent of the incident light.

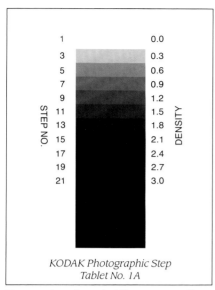

STEP NO.	DENSITY
1	0.0
3	0.3
5	0.6
7	0.9
9	1.2
11	1.5
13	1.8
15	2.1
17	2.4
19	2.7
21	3.0

KODAK Photographic Step Tablet No. 1A

To generate a characteristic curve, a section of film is carefully exposed through a step tablet (above) in a sensitometer. The densities of the step tablet are measured and plotted (right).

A Typical Characteristic Curve

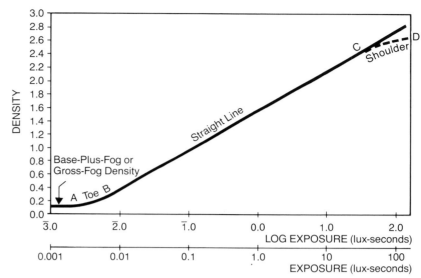

metallic silver in the developed image. The diffuse-highlight density in a properly exposed and processed negative will be within the range from 0.90 to 1.40. Although negatives may include higher densities, continuous-tone negatives with densities greater than 2.50 will be very difficult to print.

When film is exposed in a sensitometer as described earlier, the amount of exposure given to each step is specified in terms of the light intensity multiplied by the exposure time. As indicated in the curve shown above, the exposure units are called lux-seconds.† Plotting the densities in the film against the logarithms of the corresponding exposures produces a curve that is easy to interpret. In the illustration, the corresponding lux-second values are shown below the log exposure values.

†A piece of film placed 1 metre from a standard candle is illuminated by light with an intensity of 1 lux. If it is exposed to this light for 1 second, it receives an exposure of 1 lux-second.

The characteristic curve generated from readings made from a test negative represents the characteristics for that film/process combination.

Representative characteristic curves are curves that are typical of a product; they are produced by averaging the results of many tests made on a number of production batches of film. The curves in the Data Sheets (pages DS-2 to DS-26) are representative characteristic curves.

Curve Shape

Because of its shape, the characteristic curve is generally divided into three distinct regions. In the illustration of a typical curve shown above, section AB is called the toe, BC is the straight line, and CD is the shoulder.

The shapes of the characteristic curves of different films vary. The toe may be short or long. The straight-line portion may be long and relatively straight, or it may be curved. With some films, the curve may continue upward, like an extended toe, throughout the useful exposure range of the film. The following sections explain how curve shape affects negative-making.

Base-Plus-Fog Density: The section to the left of A is a horizontal line that represents the region of exposure in which the film gives no response. The unexposed edge of a negative has this density. It is called the base-plus-fog or gross-fog density.

The Toe: The toe, the crescent-shaped lower part of the characteristic curve, extends from A to B. In this region, tones are compressed, and the rate of density change for a given log exposure change increases continuously. In practice, this means that the separation between shadow densities in the negative becomes progressively less as the exposure approaches the lower end of the toe. Densities that are less than 0.10 density unit greater than the base-plus-fog level usually print as black without detail. The shape and length of the toe varies from film to film. Films are typically described as short-toed or long-toed. Short-toed films expand shadow tones more than long-toed films. This makes short-toed films ideal for high-flare conditions, in which shadow tones are compressed.

The Straight Line: If the straight-line portion of a characteristic curve is truly straight, the midsection of the curve (B to C) has a constant slope for a given log exposure change. The relationship between density and log exposure is constant. The tonal scale is compressed *evenly.*

Some films have a long straight-line portion like the one shown in the illustration on page 9; others have little or no straight-line portion. A change of a few degrees in the slope of the line usually does not make a visible change in tone reproduction. In other words, the line may be considered straight even though it has a slight bend or curve in it.

The slope—or gamma—of the straight-line portion (a measure of the angle it makes with the horizontal axis) is an important measure of contrast; film emulsion characteristics and development determine the slope.

The Shoulder: As shown by the dotted line in the upper part of the curve on page 9, the shoulder (C to D) is the region where the slope of the characteristic curve decreases, and the curve becomes a horizontal line again. With most films, the shoulder is seldom used in practical negative-making. If you expose highlights on the shoulder of the curve of a film, you lose tone separation and block the highlights. (This means that most highlights will print with very little detail.) Most Kodak films for normal-contrast applications have long straight-line portions, which provide excellent tone separation in the highlights, even when negatives are slightly overexposed.

Grossly overexposed negatives are difficult to print because of high density, increased graininess, and decreased sharpness. Proper exposure of film is the first step toward good print quality.

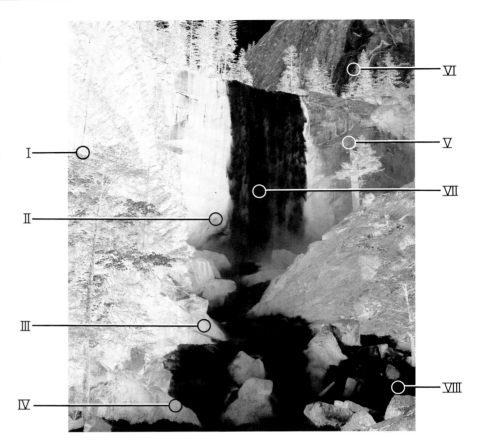

The illustrations on these two pages show the relationship between subject brightness, negative density, and the characteristic curve. (The graph shows where different brightness levels normally fall on the characteristic curve.) In the actual scene, there is a one-stop difference in brightness between each two consecutive zones. In the print, Zones IX and X (not shown) would reproduce as white. The zones used here correspond to the Zone System described in The Negative, *by Ansel Adams.*

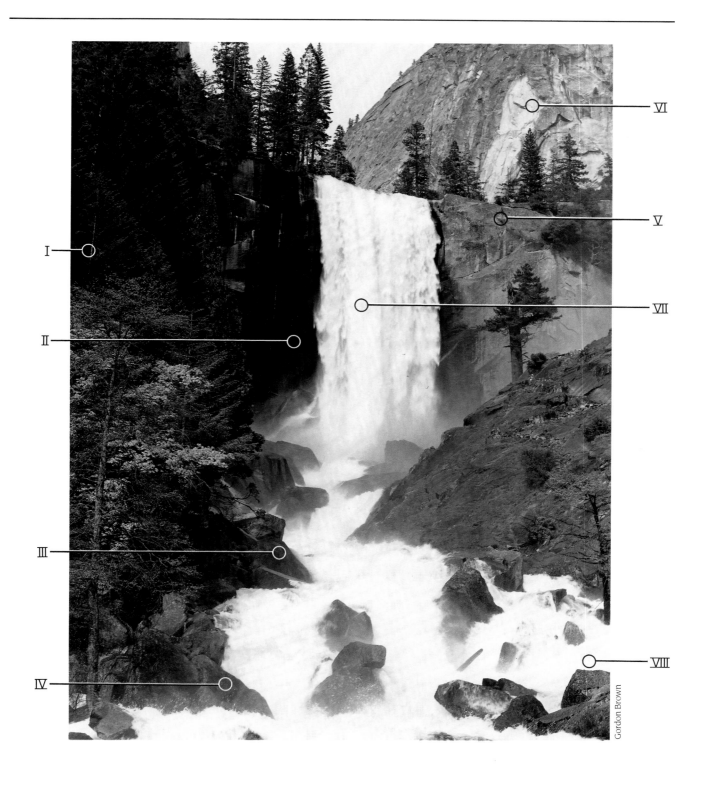

I

II

III

IV

VI

V

VII

VIII

Gordon Brown

The extremely fine grain and very high resolving power of KODAK T-MAX 100 Professional Film make it an excellent choice for commercial applications.

MEASURING THE SUBJECT-LUMINANCE RANGE

In many photographic situations, the subject contrast (subject-luminance or brightness range) will be higher or lower than the 7-stop range that is considered normal (excluding specular highlights and shadows that will print as black with no detail).

To find the subject-luminance range, measure two areas of the subject with a spot meter or make close-up readings with an averaging reflected-light exposure meter. First measure a diffuse-highlight area and calculate an exposure for that area; use a shutter speed near the middle of the range. Then measure a shadow area that should reproduce just lighter than black; calculate an exposure for this area at the same shutter speed you used for the highlight area. *The number of stops between the f-numbers for the two exposures is the luminance range (in f-stops).* This range will usually be about 7 stops for typical full-scale subjects; examples of subjects with low and high luminance ranges are shown in the photographs on page 36. Few subjects have luminance ranges that are less than 5 stops or greater than 9 stops.

You can develop sheet film or entire rolls exposed to scenes with the same subject-luminance range to a contrast index that will produce negatives with nearly normal density ranges.

EXPOSURE

Correct exposure is one of the most important factors in achieving the best possible photographic quality. Knowing the speed of the film is the starting point for determining correct exposure. However, film speeds are not rigid specifications that you must never modify.

The film speed you use will depend on the film, exposure conditions, developer, and development conditions (time, temperature, and agitation). For example, use of fine-grain developers, such as KODAK PROFESSIONAL MICRODOL-X Developer, will produce a loss of film speed compared to processing the same film in a standard developer, such as KODAK PROFESSIONAL Developer D-76. Therefore, you may need to use a lower speed rating to expose the film if you use MICRODOL-X Developer.

When you increase development to increase the contrast of negatives of low-contrast subjects, the effective film speed is usually increased slightly. On the other hand, reducing development to produce negatives for printing with a condenser enlarger or to compensate for high-contrast subjects lowers the effective film speed. To produce negatives consistent in overall density and quality, you should make an exposure compensation when you adjust development times.

The amount of error in your camera-aperture settings and shutter speeds also affects the film-speed rating that you should use. Factors such as lens coating and the number of lens elements play a part in the light transmission of a lens. Make tests with your equipment and films to determine effective film speeds that produce high-quality negatives. Monitor your photographic results routinely to verify that the film speed you use continues to be correct.

The information on making an exposure/development ringaround (page 21) provides a "convenient" method of determining the best film speed for your application.

Calculating Exposure

On sunny days, the brightness of subjects in sunlight is relatively constant. For average frontlighted subjects, you can determine the exposure by following the rule

$$\frac{1}{\text{film speed}} \text{ second at } f/16$$

To determine exposure for outdoor subjects without using an exposure meter, you can follow the guidelines in the table below:

Lighting Conditions	Subject Conditions	Exposure	
	On Light Sand or Snow	−1 stop	
Bright or Hazy Sun	Average Subject	$\frac{1}{\text{film speed}}$	second at $f/16$
	Sidelighted Subject	+1 stop	
Cloudy Bright (No Shadows)	Average Subject	+2 stops	
Heavy Overcast or Open Shade*	Average Subject	+3 stops	

*Subject shaded from the sun but lighted by a large area of sky.

Using an Exposure Meter

For subjects illuminated by other light sources (e.g., incandescent illumination), the conditions are so variable that no easy formula will help you calculate exposure. In these situations, it is best to use an exposure meter.

For information on using three common types of exposure meters, see the *KODAK Professional Photoguide*, Publication R-28. An incident-light meter measures the amount of light falling on the subject. This type of meter is most useful in studio work with incandescent illumination. Averaging reflected-light meters and spot meters are the most useful types for determining exposure in daylight. They can also help you determine the brightness range of a scene so that you can develop the film to a contrast index that is appropriate for the scene.

One method of using a reflected-light meter requires a *KODAK Gray Card* (Publication R-27). The gray card has a neutral gray side that reflects 18 percent of the light falling on it.

To determine exposure, position the gray card so that it faces your camera. Be sure that there are no shadows on it, no brightly colored objects reflecting light on it, and no glaring (specular) reflections on it. In artificial light, position the card close to and in front of the subject, aimed halfway between the main light and your camera. In daylight, position the card facing the camera and as close to the subject as possible. Or you can make an exposure reading of the card near your camera, as long as you position the card so that it receives the same angle and intensity of illumination as the subject. To be sure you read only the card, hold your meter about 6 inches (15 cm) from the card. If you are using a spot meter or a single-lens-reflex camera with a built-in meter, you can see exactly what you are reading.

Note: If you make a reflected-light meter reading from a gray card with incandescent illumination in the studio, use the exposure indicated by the meter. If you use the gray card to determine exposure outdoors in sunlight, increase the exposure indicated by the meter by 1/2 stop.

CONTRAST

Negatives with the correct contrast range will produce good-quality prints when you print them on normal-contrast (grade 2) paper with your equipment.

A number of factors determine negative contrast:

- Subject-luminance ratio (brightness range)
- Film characteristics
- Subject conditions that contribute to flare
- Flare level of the camera and lens
- Exposure (see page 13)
- Film development (which depends on the developer type; dilution, degree of exhaustion, and temperature of the developer; frequency, duration, and degree of agitation; and development time)

Lens flare can degrade an image. It lowers the brightness range of the subject, and can form streaks and hexagons (from the lens diaphragm) on the film. Lens flare occurs most frequently when you use harsh side- or backlighting. (Zoom lenses are especially susceptible to lens flare because they have several glass elements.) If flare is a problem, use a lens hood or shade.

In general, varying the amount of development will be your primary control in producing negatives with a density range that will print well with your equipment.

You can use several methods to determine the amount of development a film requires. Three methods are covered in the following sections: time/temperature tables, gamma and contrast index, and ringaround tests. You may find that using only the time/temperature tables will provide the easiest method. However, by using the time/temperature tables with gamma or contrast-index measurements or a ringaround test, you can accurately adjust these times to suit your application and equipment.

Time/Temperature Tables

The tables in the Data Sheets at the back of this book give development times based on developer temperature. These times should produce average-contrast negatives of normal-contrast scenes. However, they are based on exposures made through lenses with moderate flare and are intended to produce negatives that will be printed with diffusion enlargers. Most negatives developed according to the tables will be too contrasty (or too dense) to print on a normal-contrast paper with condenser enlargers. (If the scenes are contrasty, the negatives may not be printable on even the lowest-contrast paper.) To print on a normal-contrast (grade 2) paper with a condenser enlarger, you will need to adjust exposure and development time to produce negatives with less contrast (see page 22).

If you normally photograph a wide variety of subjects under different lighting conditions with different lenses, you will produce negatives with a variety of density ranges. Normally, you can print a variety of negatives satisfactorily by using graded papers or a selective-contrast paper.

Using the values in the time/temperature tables as starting points, run your own practical tests to determine a development time for a given film/developer combination that will produce negatives with a contrast that is appropriate for your printing equipment.

Gamma and Contrast Index

Several methods of classifying negative contrast are available. Two especially useful measurements of contrast are gamma and contrast index.

Gamma is the more traditional method. Gamma is useful in scientific and technical photography; however, contrast index is frequently used in general pictorial applications.

Portrait made on KODAK PLUS-X Pan Professional Film, 120 size.

Gamma (γ) is the slope of the straight-line portion of the characteristic curve. Historically, it indicated how much tone compression occurred between the optical image and the negative. A negative with a gamma of 0.60 has a tone compression of 6/10 in the tones that are recorded on the straight-line portion of the characteristic curve of the film. If two tones in the optical image have a density difference of 1.0, and the film used to record them is developed to a gamma of 0.60, the density difference between the two tones will be 0.60 in the negative. This indicates how much the tones are compressed.

Because gamma measures only the straight-line portion of the characteristic curve, it is not a good indicator of negative contrast in pictorial photography. Two different films developed to the same gamma may yield negatives with different density ranges. This is most noticeable when the characteristic curves of the films differ in the toe region, which gamma calculations ignore.

Contrast index (CI) is the slope of a straight line drawn through three points on the characteristic curve. One point is on the toe; it represents an open, detailed shadow. Another point represents the base-plus-fog density. The third point usually falls on the straight-line portion below the shoulder; it represents a diffuse highlight. The major benefit of contrast index is that it helps you determine development times that give consistent negative density ranges. If you find, for example, that negatives made on one black-and-white film developed to a CI of 0.56 print well on a grade 2 paper with a diffusion enlarger, you can develop other films* to the same CI, and expect to get a similar negative density range when the subject-luminance range is the same. You can determine development times by using contrast-index curves (see page 18).

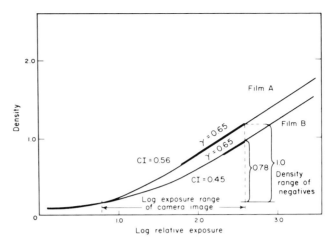

Figure 1

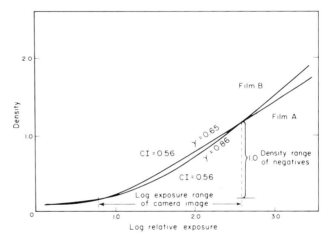

Figure 2

Gamma vs Contrast Index: Figure 1 (above) shows the characteristic curves of two films—one with a medium-length toe (Film A) and one with a long toe (Film B). Both films show normal exposures of a pictorial subject with the same luminance ratio or exposure range. These films were developed to the same gamma (0.65). Film A has a density range that will produce a print of good quality on normal-contrast paper; Film B has a density range that is too short to produce a good continuous-tone print on normal-contrast paper.

Figure 2 (above) shows the characteristic curves of the same two films exposed as in Figure 1 but developed to the same contrast index (0.56). Films A and B now have equal density ranges, and the negatives from both films will produce good-quality prints on normal-contrast paper. The average gradients of the parts of the curves on which the subject is recorded are now equal; the gammas of the films are unequal.

*KODAK T-MAX 400 Professional Film is an exception; the aim contrast index for T-MAX 400 Film is 0.04 higher than that for other black-and-white films.

Developing films to the same contrast index makes it easier to control contrast in prints and leads to more consistent results. Controlling the negative density range is important in obtaining the widest possible range of tones in a print.

Many photographers use contrast-index measurements because they are flexible and lead to more consistent negative density ranges under a variety of conditions. Especially in outdoor scenes, subject contrast is determined by the subject-brightness range and the lighting. The contrast provided by the enlarger depends on its type (diffusion or condenser) and the quality of the enlarger lens. Even though you can control print contrast by using papers with different contrast grades or selective-contrast papers with filters, you should strive to produce negatives that consistently print well on grade 2 (normal-contrast) paper.

When the subject-luminance range is greater or less than 7 stops, you can develop your film to a different contrast index to obtain the density range that you would normally achieve in negatives of full-scale subjects. For subjects with a luminance range less than 7 stops, develop to a higher contrast index. For subjects with a luminance range greater than 7 stops, develop to a lower contrast index. (See page 13 for information on measuring the subject-luminance range.)

Determining Contrast-Index Values from Characteristic Curves:

To determine the contrast index of a film from its characteristic curve, first draw a straight line parallel to the horizontal axis at the base-plus-fog level (see Figure 3). This is the density of the clear edge of the film after processing; on the curve, it is the lowest part of the toe, where the characteristic curve is parallel to the horizontal axis.

Then mark a straightedge—the edge of a piece of paper works well. Put the following marks (using the same scale as that on your graph paper) on the straightedge—a mark at zero, one at 0.20 density (log

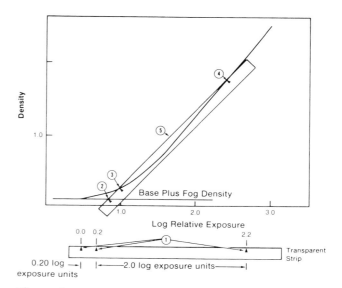

Figure 3

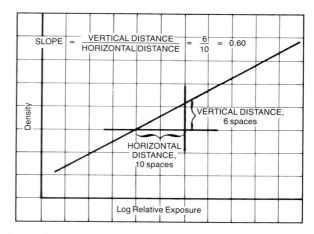

Figure 4

exposure) unit, and one at 2.2 density units—see the illustration (1) below the graph of Figure 3. Place the straightedge on the characteristic curve so that the 0.2 mark (3) is on the toe and the 2.2 mark (4) is on the straight-line portion. Slide the straightedge up and down, keeping the marks on the curve, until the zero mark (2) falls on the base-plus-fog line. Mark these three points and draw a straight line to connect them (5). The slope of this straight line is the *contrast index.*

To determine the slope of the line, pick any point on the straight-line portion and count 10 small units to the right. Then count the number of small units back up to the straight line (see Figure 4). Divide the vertical distance by the horizontal distance to determine the contrast index.

For example:

$$\text{Slope} = \frac{\text{Vertical Distance}}{\text{Horizontal Distance}} = \frac{6}{10} = 0.60$$

The contrast index for the film used in the example is 0.60.

Starting-Point Recommendations for Contrast Index and Density

Range: The appropriate contrast index for a negative depends on the type of enlarger you use. Starting-point recommendations for contrast index and density range for diffusion and condenser enlargers are given in the table below. Different enlargers have different contrast characteristics. Most diffusion enlargers print with approximately the same contrast characteristics. This group of enlargers includes those that have incandescent bulbs and opal-glass or ground-glass diffusers, and color heads with integrator reflecting surfaces that diffuse the light from one or more incandescent or pulsed-xenon bulbs.

The contrast characteristics of a condenser enlarger that are used as the standard in this publication are those of a typical condenser enlarger with an opal incandescent enlarging bulb and condensers that have polished surfaces. Some condenser enlargers have a condenser that has at least one unpolished (ground) surface. The contrast characteristics of this type of enlarger will fall between those of a typical condenser enlarger and a diffusion enlarger because one of its condensers partially diffuses the light. Another type of condenser enlarger (called a point-source enlarger) has a clear bulb with a small filament; this type produces higher print contrast than a typical condenser enlarger. Negatives that you print with a point-source enlarger will require a lower density range than negatives produced for printing with typical condenser enlargers.

Recommended Contrast Index and Density Range for Printing on Grade 2 Paper with Different Enlarger Types

Enlarger Type	Contrast Index*	Density Range
Diffusion	0.56	1.05
Opal-Bulb Condenser	0.42	0.80
Small-Filament-Bulb Condenser	0.38	0.73

*For T-MAX 400 Professional Film, add 0.04 to these contrast-index values.

Darkroom conditions can also lower print contrast. Light leaking around the edges of a negative in the negative carrier increases flare and reduces contrast. A dirty enlarger lens, an incorrect safelight filter or unsafe safelight, excessive exposure to a safelight, and stray light from an enlarger head can also reduce print quality and contrast. You must control these variables to obtain best results when you follow the procedures in this publication.

Proper matching of negative density range and paper contrast is not the whole story in achieving good tone reproduction. Aesthetic factors also help to determine what makes a good-quality print of a particular subject. For example, a particular subject may require an increase in midtone separation.

Using Contrast-Index Curves:

Once you know the negative density range that prints best on grade 2 paper with your enlarger, you can aim for this density range in all negatives by developing films to the same contrast index.* To determine the development time for another film, refer to the contrast-index curves on the Data Sheet for the new film. Use the development time that corresponds to your developer and the contrast index that you determined for your "control" film.

You can also use contrast-index curves to determine the development time for using another developer for your "control" film. To determine the development time for another developer, locate the point where the contrast-index curve for the new developer intersects the contrast index value that you used for the other developer. Then locate the development time on the horizontal axis.

Other Considerations for Contrast Index:

Extending development times to achieve a contrast index higher than those given in the Data Sheet for your film/developer combination, or using times longer than twice the time recommended for producing the nominal contrast index for your film, may not give satisfactory results. (Printing on a higher-contrast paper is one way to make up for the lower density ranges.)

The contrast-index curves for some film/developer combinations become virtually horizontal as development time increases. If you require a higher contrast index than a particular developer can achieve, choose another developer using the contrast-index curves on the Data Sheets as a guide.

*If you calculate the contrast index for your equipment by running tests with T-MAX 400 Professional Film, subtract 0.04 from the value for T-MAX 400 Film to determine aim CIs for other continuous-tone normal-contrast films.

KODAK T-MAX 400 Professional Film is gaining popularity in industrial applications.

Shortening development times will produce a lower contrast index. Choose a developer (or a developer dilution) that requires a development time longer than 5 minutes for the film you intend to use. Avoid tank-development times shorter than 5 minutes (4 minutes with KODAK PROFESSIONAL XTOL Developer), because they may produce negatives with unsatisfactory uniformity.

Extrapolating the curve and using shorter development times than those given in the Data Sheets to obtain a lower contrast index may also give unsatisfactory results. Run tests by using the estimated development time; if your results are not satisfactory, adjust the development time or the film-speed rating (or both) and run another test before you expose and process film for critical applications.

Increased Midtone Separation: The ringaround procedure (described on page 21) is designed to help you produce negatives with a density range that matches the log exposure range of the paper when the negatives are printed with an enlarger of the type used to calculate the contrast index. This provides typical tone reproduction.

Some photographers find that they prefer prints with slightly more midtone separation than the ringaround procedure provides. To obtain greater midtone separation, lengthen the development time until you produce a negative that prints well on grade 1 paper, and then print the negative on grade 2 paper. You can use dodging and burning-in techniques to retain shadow and highlight detail.

For greater midtone separation, your negatives should have a density range of 1.25 for printing with a diffusion enlarger or 0.95 for printing with a condenser enlarger (instead of the normal density ranges of 1.05 for diffusion enlargers and 0.80 for condenser enlargers).

Bob Clemens

Large, even-toned areas in the midtones of a photograph will appear more grainy than dark- or light-toned areas. To minimize the graininess, you can use a film with extremely fine grain, such as KODAK PROFESSIONAL Technical Pan Film. The extended red sensitivity of Technical Pan Film helps diminish the appearance of blemishes in portraits.

Artistic Considerations: The contrast-index adjustments described on page 17 are based on the assumption that you want to use the full tonal scale of normal-contrast paper when you print negatives of low- and high-contrast subjects, and that you want to avoid producing negatives with density ranges that will make printing difficult. Tonal separation is increased in negatives of low-contrast subjects and is decreased in negatives of high-contrast subjects. This is generally acceptable for most subjects because the tonal separation is improved in the print.

However, you may sometimes want to reproduce subject contrast as it appeared in the original scene. For low-contrast subjects, develop the film to the contrast index used for normal-contrast subjects. For subjects with extremely low contrast, use a contrast index that is halfway between the contrast index for normal subjects and the adjusted contrast index for low-contrast subjects. This partial adjustment will increase the tonal separation (but not as much as if you used the whole adjustment) and make printing easier.

Reproducing extremely high-contrast subjects accurately is not as simple. Developing the film to the contrast index required for normal subjects (or to a compromise contrast index) is likely to produce negatives with density ranges beyond the scale of the lowest-contrast paper. If this occurs, you can modify the density of the negative as described in the next section. It is usually best to determine exposure by using the method described on page 13 to record the subjects with adequate shadow detail.

Ringaround Tests

A good negative is one that yields high-quality prints. The aim is to produce negatives of typical subjects with a contrast that will print well on a normal-contrast (grade 2) paper with your enlarger.

The correct development time for your film/developer combination will produce this contrast. If you expose the film to subjects with lower or higher contrast and develop the film for the same time as film exposed to normal-contrast subjects, you will produce negatives of lower or higher contrast. To obtain normal-contrast prints from these negatives, you can print them on a higher- or lower-contrast paper.

Striving for negatives that will print well on a normal-contrast paper is a good practice for two reasons:

1. *Ease of printing.* You will be able to print most of your negatives—those with average contrast—without difficulty on normal-contrast paper, and you can use papers of higher or lower contrast to accommodate negatives of scenes with contrast that is higher or lower than the average.

2. *Improved tone reproduction.* When low-contrast negatives are printed on some high-contrast papers, a larger percentage of the tonal scale is printed on the toe of the characteristic curve of the paper and a smaller percentage of the scale is printed on the straight-line portion of the curve. Because the toe of high-contrast papers is steeper than that of normal-contrast papers, the midtones will be darkened and the light tones compressed. Development of negatives to print on a low-contrast paper gives slightly improved tone reproduction for most subjects, but it eliminates the tolerance for high-contrast subjects provided by aiming for negatives that will print on a normal-contrast paper.

To determine the best exposure and development time for your film and application, make a ringaround test of a typical full-scale subject with exposure and development variations. If you photograph a variety of subjects under different lighting conditions with a variety of black-and-white films and lenses, you may want to make several ringarounds, one for each set of conditions.

Making a Ringaround: The illustration on page 23 shows a ringaround made on KODAK T-MAX 100 Professional Film. A ringaround should yield one negative that has the correct exposure and development for your printing conditions.

Exposure: If your typical subject is frontlighted by bright sunlight, the normal exposure will be 1/film speed at $f/16$ (or an equivalent exposure). If you are using T-MAX 100 Professional Film, for example, the shutter speed would be 1/125 second, because it is closest to the film speed of EI 100.

If your typical subject is an indoor subject lighted by electronic flash, run a guide-number test* first. Once you determine the correct guide number from the test, set your flash on manual. To determine the lens opening, divide the guide number by the flash-to-subject distance.

With incandescent illumination (e.g., studio lights) or daylight (other than that described earlier), use an exposure meter to determine the normal exposure.

If you develop your film according to the time/temperature tables, expose the film at the speed given in the instructions packaged with the film or the speed given in the Data Sheet (pages DS-2 through DS-26). If you develop the film for a shorter time than the table recommends (e.g., to obtain lower contrast), increase exposure by approximately ⅔ stop to avoid underexposure. The sample ringaround shows the results of exposure and development variations.

*To find the best guide number for your flash unit, place an average indoor subject 10 feet from your flash. Load your camera with a color-slide film, preferably one that has the same film speed as the black-and-white film you will use for the ringaround. Set the flash on manual. Make an exposure series at ½-stop intervals—$f/2.8, 3.4, 4, 4.7, 5.6, 6.7, 8, 9.5, 11, 13,$ and 16. For each exposure, record the f-number you are going to use in large writing on a card, and place the card in the scene. Wait at least 15 seconds after the flash "ready" light glows to make sure that the unit is fully charged. Process and view the slides normally, and choose the best exposure. Multiply the f-number you used for the best exposure by 10 (feet), the flash-to-subject distance. Your answer is the guide number (for distances in feet) to use with that flash unit, camera, and film speed. Use the equation below to determine the guide number for a film with a different speed:

$$\text{New guide number} = \text{Old guide number} \times \sqrt{\frac{\text{New film speed}}{\text{Old film speed}}}$$

1	6	11	16	21
+2 stops with 30% less development	+2 stops with 15% less development	+2 stops with normal development	+2 stops with 15% more development	+2 stops with 30% more development
2	**7**	**12**	**17**	**22**
+1 stop with 30% less development	+1 stop with 15% less development	+1 stop with normal development	+1 stop with 15% more development	+1 stop with 30% more development
3	**8**	**▶13**	**18**	**23**
normal exposure with 30% less development	normal exposure with 15% less development	normal exposure with normal development	normal exposure with 15% more development	normal exposure with 30% more development
4	**9**	**14**	**19**	**24**
−1 stop with 30% less development	−1 stop with 15% less development	−1 stop with normal development	−1 stop with 15% more development	−1 stop with 30% more development
5	**10**	**15**	**20**	**25**
−2 stops with 30% less development	−2 stops with 15% less development	−2 stops with normal development	−2 stops with 15% more development	−2 stops with 30% more development

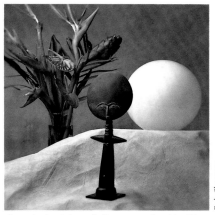

A contact print made from negative No. 13

Development: The development times given in the Data Sheets at the back of this book are intended to produce normal-contrast negatives from average-contrast subjects. The negatives will normally print well on a normal-contrast (grade 2) paper with a diffusion enlarger. If you use a diffusion enlarger, use the development times given in the Data Sheet for your film/developer combination. This will be your *normal development time* for the ringaround.

To print on a normal-contrast (grade 2) paper with a condenser enlarger, you will need to adjust exposure and development time to produce negatives with less contrast. For T-MAX Professional Films developed in black-and-white chemicals, increase exposure by 1/3 to 1/2 stop and reduce the development times given in the Data Sheets by about 15 percent. For other films, increase exposure by 1/3 to 1/2 stop and reduce the development times by about 20 to 30 percent. For KODAK PROFESSIONAL T-MAX Black-and-White Film T400 CN,

contrast can be altered using the push processing speeds and times specified on the Data Sheet (pages DS-6 and DS-7).

Once you have selected the nominal exposure and development time, you are ready to calculate the exposure and development times for each strip of negatives in the ringaround.

Note: If you use T-MAX 100 or 400 Professional Film for your ringaround, use all 5 columns of exposure and development variations in the chart. If you use a film other than T-MAX 100 or 400 Film, you can skip some of the variations: If you use a **condenser enlarger**, skip the two columns of exposures at the right side of the chart; if you use a **diffusion enlarger**, skip the column at the left side of the chart.

Calculating Development Times for the Ringaround: When you need to reduce the nominal development time, subtract the amount of change (percentage) from 100 percent, move the decimal point two places to the left, and multiply the

time by this figure. For example, if your nominal development time is 8 minutes, and you want to reduce development by 30 percent,

$$100\% - 30\% = 70\%$$
$$70\% = 0.70$$
$$0.70 \times 8 \text{ minutes}$$
$$= \text{approximately } 5^{1}/_{2} \text{ minutes}$$

To find the new development time when you need to increase the nominal time, add the amount of change (percentage) to 100 percent, move the decimal point two places to the left, and multiply the time by this figure. For example, if your nominal development time is 11 minutes, and you want to increase it by 30 percent,

$$100\% + 30\% = 130\%$$
$$130\% = 1.30$$
$$1.30 \times 11 \text{ minutes}$$
$$= 14.3 \text{ minutes}$$
$$= \text{approximately } 14 \text{ minutes } 20 \text{ seconds}$$
$$(\text{round to } 14^{1}/_{2} \text{ minutes})$$

With roll films, use a different roll for each column of the chart. Develop each roll according to the descriptions in the chart.

After processing, print the negatives from your ringaround on a grade 2 paper (or a selective-contrast paper with a No. 2 selective-contrast filter). Make the best print that you can from each negative. Process the prints according to the instructions packaged with the paper.

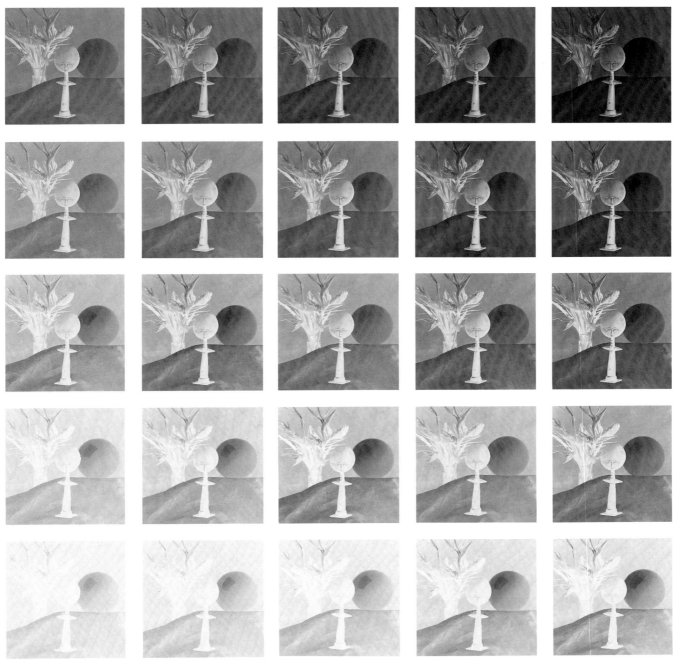

The negatives in the ringaround above are identified in the chart on page 22. Negative No. 13 represents normal exposure and normal development for printing with a diffusion enlarger.

Evaluating the Ringaround: Arrange the prints in the order shown in the chart on page 22, and judge the quality. Find the print with the best contrast and shadow detail. If the contrast of the print is "just right" and the print shows the right amount of shadow detail, you have found the correct film speed and development time for your conditions.

Occasionally, none of the prints will show the right combination of contrast and shadow detail. The best print may have insufficient shadow detail because the film was underexposed, or the contrast may be too low because the development time was too short. You may find that the exposure (or development) required to produce a negative with the best contrast and the right amount of shadow detail falls between two of the exposures from your original ringaround. For example, the exposure of the normally exposed and developed negative may be correct, but the contrast may be slightly low, and the contrast of the normally exposed 15-percent-overdeveloped negative may be slightly high. In this case, a development time halfway between the two will probably be appropriate; try processing a normally exposed negative with a development-time increase of 7 to 8 percent over the normal time.

Contrast Index of Your Best Negative: After you select the best negative from your ringaround, determine its contrast index. Determining the contrast index is easy; on the Data Sheet for the film, find the contrast-index curve for the developer that you used. Locate the point where your development time intersects the curve; then determine the contrast-index number for that development time. To determine the development time for another film,* refer to the contrast-index curves on the Data Sheet for the new film. Use the development time that corresponds to your developer and the contrast index that you determined for the film you used for the ringaround.

Adjusting Development to Scene Contrast (Luminance Range): If you photograph a scene with higher or lower contrast than the scene you used for your ringaround, you can change the development time to adjust the negative contrast so that the negative will print well on a normal-contrast paper and provide improved tone reproduction. Use the normal development time determined by your ringaround when you want to preserve the contrast of the scene.

Changing the development time affects highlights more than midtones and shadows. A longer development time increases negative contrast and expands highlights and midtones, making them appear lighter in the print than they would with normal development. A shorter development time reduces negative contrast and compresses the highlights and midtones, making them appear darker in the print than they would with normal development.

Development is usually shortened for scenes of very high contrast, such as a dark room with a large window that provides a view of the bright outdoors, or a sunlit snow-covered field that includes dark shadows. A high-contrast scene has an 8- or 9-stop range from the shadows to the diffuse highlights. (A normal scene has a 7-stop range.) If film exposed to a high-contrast scene is developed normally, the negatives will be difficult to print. The highlights would be almost paper-white and would show little, if any, texture. Shortening the development time will make the negative easier to print.

The development time for film exposed to a low-contrast scene (e.g., a foggy landscape) is usually increased. A low-contrast scene has only a 5- or 6-stop range from the shadows to the diffuse highlights. If film exposed to a low-contrast scene is developed normally, the negatives will produce low-contrast (flat) prints. Increasing development will improve contrast; however, it will also increase graininess, which makes this technique less suitable for small-format films. When you increase development with small-format films, you must decide if the benefits of an expanded tonal range will offset the increase in graininess.

How much should you shorten or lengthen the development time? That depends on scene contrast and your equipment and development techniques. To determine new development times accurately, make ringaround tests for high- and low-contrast scenes. You will probably need to adjust the film-speed rating that you use. If you reduce development for high-contrast scenes, decrease the speed rating. If you increase development for low-contrast scenes, increase the speed rating. For ringaround tests of these scenes, vary development by increments of 30 percent for conventional films and by 15 to 20 percent for T-MAX Films developed in black-and-white chemicals. Find the negative that prints best on a normal-contrast paper. As described earlier, determine the contrast index of your best negative and develop other films exposed under similar conditions to that contrast index.†

The ringaround method was designed to produce proper contrast for normal-contrast subjects. It relies on the different contrast grades of black-and-white papers to compensate for variations in subject contrast.

*The aim contrast index for T-MAX 400 Professional Film is normally 0.04 higher than that for other black-and-white films. If you use T-MAX 400 Film to produce your ringaround, subtract 0.04 from the contrast index that you calculate, and then use the adjusted contrast index for other films.

†If you produced your best negative on T-MAX 400 Professional Film, subtract 0.04 from the contrast index to calculate your aim CI for producing negatives with normal contrast on other films.

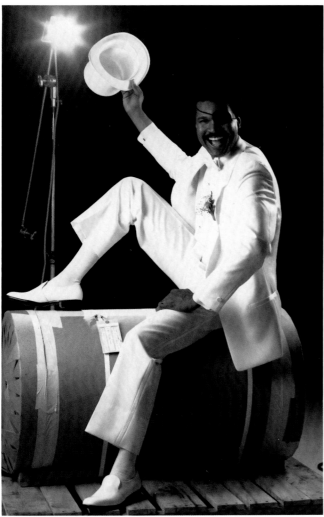

Normal Development

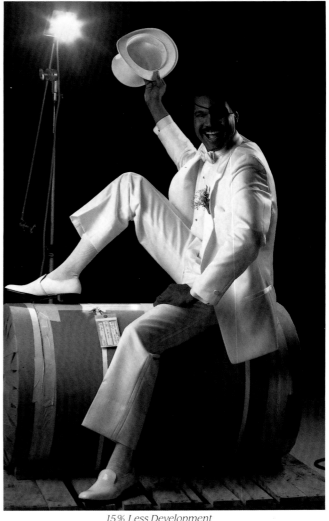

15% Less Development

<div style="float: right">Sam Campanaro</div>

When recording the highlight detail in a moderate- to high-contrast scene is important—as in this photo of a man in a white tuxedo—you can reduce development to maintain detail. In this example, one roll of T-MAX 100 Professional Film was developed normally, and the other was developed for 15 percent less time. (Remember that underdevelopment reduces film speed.)

Both negatives were exposed for the same time on the same grade of paper. Notice the improved highlight detail in the negative that received less development. (The highlight detail in the print made from the normally developed negative could have been improved with a longer exposure time and burning in.)

Post-Processing Density Controls

At times, you may want to alter negatives to improve the quality of the prints they produce or to make multiple matched prints more easily. You can use a number of techniques on improperly developed negatives, negatives exposed under spotty or harsh lighting, or negatives from which you want to make many identical prints. You can also improve the tones of a subject to produce a more effective print.

Changing local densities in a negative can improve its printing characteristics and help you produce a high-quality print without dodging. (If you plan to make only a few prints from a negative, it may be easier to use dodging as your primary control.)

It is easier to balance local areas accurately if you work with a large negative. If you must reduce or intensify the tones in a small image, you can make a larger copy negative to work on.

If you are unsure of the effects that reducing and intensifying will have in the print, first make an enlarged interpositive of the negative image. You can make the interpositive on a film with relatively low contrast or a film with moderately high contrast. Make the interpositive the largest size that will fit your enlarger so that you can contact-print it to produce the copy negative. As you expose the interpositive, you can dodge or burn in parts of the image. After you've processed the interpositive,

use reduction or intensification techniques to adjust density locally (see below). To produce the copy negative, contact-print the interpositive. *Use a film with moderately high contrast* (e.g., KODAK PROFESSIONAL Technical Pan Film processed in KODAK PROFESSIONAL HC-110 Developer [Dilution B or D]) *if you used a film with relatively low contrast to produce your interpositive; use a film with relatively low contrast* (e.g., KODAK T-MAX 100 Professional or KODAK PROFESSIONAL EKTAPAN Film) *if you used a film with moderately high contrast to make the interpositive.* If necessary, you can use density-control techniques on the copy negative as well.

As a shortcut, you can make an enlarged copy negative on KODAK PROFESSIONAL B/W Duplicating Film SO-132 and reduce or intensify the image. (B/W Duplicating Film SO-132 does not require reversal processing. When you expose this film, remember that it is a reversal film; dodging will increase density and burning in will decrease density in the duplicate.)

You can also use T-MAX 100 Professional Film to make enlarged copy negatives if you process it with the KODAK T-MAX 100 Direct Positive Film Developing Outfit (see the instructions packaged with the outfit).

Reduction: Reduction is a chemical method of decreasing negative density. KODAK PROFESSIONAL Farmer's Reducer is the most commonly used reducer; you can purchase it from your photo dealer.

2 stops underexposed

Print made from an intensified negative

Michele Hallen

Even if you print an underexposed negative on grade 4 paper, the print may still look flat. "Intensifying" the negative to increase the density helps produce a print with more contrast, especially in the highlights.

If the density of a negative is too high but the contrast is correct, you can reduce the overall density by using KODAK PROFESSIONAL Farmer's Reducer or Farmer's Reducer R-4a*. If the density *and* the contrast are too high, reduce the negative in Farmer's Reducer R-4b*.

If the negative is too dense only in certain areas, you can use KODAK PROFESSIONAL Farmer's Reducer or etching techniques for localized reduction. Determining and controlling the amount of reduction require practice and experience.

Intensification: If a negative is too thin overall, you need to increase its density and contrast. Treatment with KODAK PROFESSIONAL Rapid Selenium Toner, diluted 1:3, increases density and contrast, especially in the midtone and highlight areas.

When highlight areas print with inadequate tone separation (this happens frequently when you use general-purpose films to make copy negatives), you can increase the tone separation by applying selenium toner locally. Apply the toner with a spotting brush, a cotton swab, or a ball of cotton.

You can also use dyes to increase the density of a negative. For example, you can mix KODAK PROFESSIONAL Crocein Scarlet (neo-coccine) to various dye strengths to provide different degrees of density. To treat large areas, first soak the negative in water; then wipe the water off with a moist ball of cotton and apply the dye. If you want to increase the density of small areas, apply the dye with a brush to a *dry* negative. You can apply the dye to the emulsion and base sides of most sheet and roll films.

*Farmer's Reducer R-4a and R-4b must be mixed from formulas available in publications on photographic chemistry.

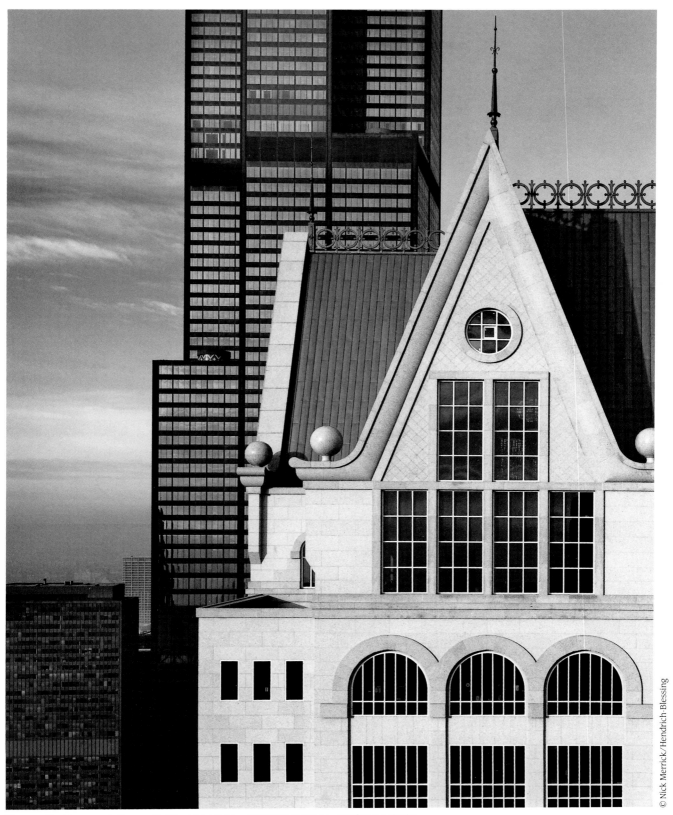

The excellent tone gradation and brilliant highlights of KODAK TRI-X Pan Professional Film have made the sheet sizes a popular choice of architectural photographers. Nick Merrick photographed this scene on 4 x 5-inch film.

Photographic Properties of Film

SPECTRAL SENSITIVITY

Spectral sensitivity means *color sensitivity*. The most commonly used black-and-white films are *panchromatic*—they are sensitive to all colors of light.

The illustration at the right shows the wavelengths of light. Energy made up of wavelengths shorter than 400 nanometres is called ultraviolet radiation. We cannot see by this type of energy—it is not visible light—but nearly all films are sensitive to it. The glass in most camera lenses absorbs ultraviolet radiation that consists of wavelengths shorter than approximately 350 nanometres; so even though films are sensitive to these shorter wavelengths, you cannot use film in a conventional camera to make photographs with ultraviolet radiation.

Gray-Tone Rendering of Colored Objects

The term *panchromatic* (as it applies to film) means that film is sensitive to all colors of light; however, it does not mean that a panchromatic film is *equally* sensitive to all colors. A photograph made of the spectrum would show a light tone in the near ultraviolet region (where the human eye sees darkness), and tones in the blue region of the spectrum would be lighter than the tones in the green, yellow, orange, and red regions. This is because the film is less sensitive to these other colors than it is to ultraviolet radiation and blue light.

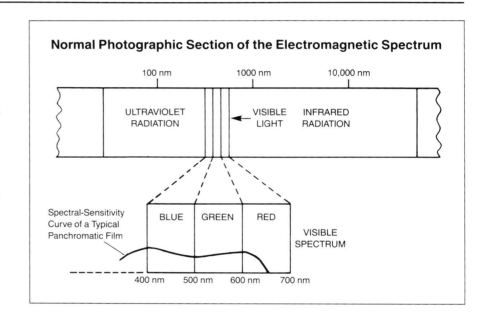

Normal Photographic Section of the Electromagnetic Spectrum

The blue sensitivity of KODAK T-MAX Professional Films (with the exception of T400 CN) is slightly less than that of other Kodak black-and-white panchromatic films. This enables the response of these films to be closer to the response of the human eye. Therefore, blues may be recorded as slightly darker tones with these films—a more natural rendition.

Filters and Filter Factors: Photographers usually intend to record colors in gray-tone equivalents of their visual brightness; however, they sometimes may want to modify the gray-tone rendering for special effects.

In general, if you want to darken the gray-tone rendering of an object or part of a scene, use a filter of a color that is complementary to the color of the object when you expose the film. For example, a yellow (No. 8) or red (No. 25) filter will darken a blue sky in your black-and-white print. To lighten a subject color, use a filter of a similar color; a blue (No. 47) filter will lighten the gray-tone rendering of a blue sky. The effects of filters on black-and-white films are explained in the table at the right.

Because filters absorb light, you must increase exposure when you use them. Lens-aperture adjustments and filter factors for use with filters in daylight and tungsten light are given in the Data Sheets. The corrections for daylight and tungsten light may differ slightly because the amount of light absorbed by the filter will vary with the color temperature of the light source. Adjust your exposure according to the table in the Data Sheet for your film: Increase exposure by the number of stops given or multiply the exposure time by the appropriate filter factor.

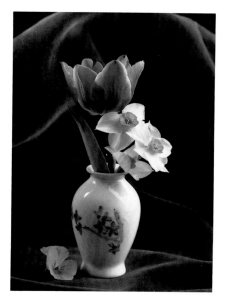 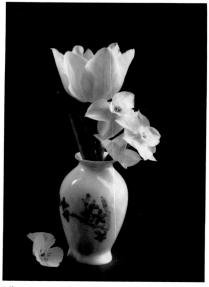

Film exposed without a filter *Film exposed through a No. 25 red filter*

Sam Campanaro

In the photograph exposed without a filter, the red tulip and the blue background are recorded with similar brightness levels. Notice how the red filter darkened the blue background and the leaf (almost to black), and how it dramatically lightened the tulip.

Effects of Filters on Black-and-White Films

KODAK WRATTEN Gelatin Filter	Color	Effect
No. 8	Yellow	Natural tone rendition. Darkens blue skies and slightly lightens foliage to improve landscapes, water, snow scenes, buildings, and other outdoor subjects.
No. 11	Yellowish-Green	Retains natural skin tones while darkening the sky in outdoor portraits. Lightens foliage to improve rendering of texture in sunlight.
No. 15	Deep Yellow	Makes blue skies darker than a No. 8 filter. Penetrates distant bluish haze in mountain scenes, aerial photos, and outdoor telephoto shots.
No. 25	Red	Darkens blue skies dramatically. Also good for scenes with light-colored buildings, trees, or snow against a blue sky. Underexposure gives a moonlight effect.
No. 29	Deep Red	Makes blue skies almost black. Lightens skin tones dramatically.
No. 47	Blue	Increases the effects of haze. Darkens skin tones, lips, and hair.
No. 58	Green	Lightens foliage. Darkens lips dramatically. Increases contrast to add dimension to faces.

Color-Sensitivity Classifications

Kodak black-and-white films are normally divided into four color-sensitivity classifications.

Blue-Sensitive: Films in this classification are sensitive only to ultraviolet radiation and blue light. In the past, blue-sensitive films with normal contrast were available; today, the only blue-sensitive films that are available have higher-than-normal contrast, and they are usually used for copying or black-and-white reversal applications. An advantage of blue-sensitive films is that you can use a safelight when you handle and process them.

Orthochromatic: Films in this classification are sensitive to ultraviolet radiation and blue and green light. You can use a safelight (usually equipped with a red filter) when you handle and process orthochromatic films. Some copy films are orthochromatic.

Panchromatic: Because panchromatic films are sensitive to all colors of light as well as ultraviolet radiation, they are used more extensively in professional photography than any other type of black-and-white film. They produce gray-tone rendering of subject colors that approximate their visual brightness and can provide a variety of gray-tone renderings when you expose them with filters. The large selection of panchromatic films offers the widest range of speeds and sensitometric characteristics (e.g., resolving power, granularity, enlargeability rating, etc.).

Extended-Red Panchromatic: Some panchromatic films, such as KODAK PROFESSIONAL Technical Pan Film and KODAK PROFESSIONAL Recording Film 2475, are more sensitive to red light than conventional panchromatic films. The extended red sensitivity of Technical Pan Film makes it useful for scientific applications, as well as for reducing the effects of haze in landscape photography. In portraiture, the red sensitivity can diminish the appearance

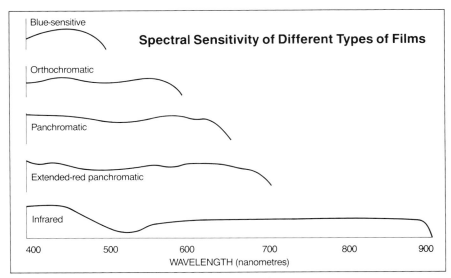

This graph shows the spectral sensitivity of each type of film.

of blemishes. Sometimes, however, it gives the subject's face a white, pasty look. To subdue the extended red sensitivity, you can use a KODAK Color Compensating Filter CC40C or CC50C. (These filters will block some of the red light.) The extended red sensitivity of Recording Film 2475 makes it an excellent choice for surveillance applications in dim tungsten light (which contains a great deal of red light that your eyes can't detect).

Infrared: Infrared films are not sensitive only to infrared radiation; they are sensitive to ultraviolet radiation and to all wavelengths of visible light as well. However, they are not very sensitive to green light. When you expose these films through a deep yellow or red filter, the filter blocks most of the ultraviolet radiation and blue and green light so that the image is formed mainly by red light and infrared radiation.

Infrared films are used primarily for technical applications (e.g., scientific, aerial, and medical photography, and photomicrography), but you can use them for pictorial applications as well. Exposing them through a red filter decreases the effects of haze to reveal distant objects with clarity.

Note: You cannot record heat loss from a building on infrared film. Photographs that show heat loss are made with a special thermographic camera that displays an image on a cathode-ray tube.

RECIPROCITY CHARACTERISTICS

All photographic emulsions are subject to an effect sometimes called "reciprocity-law failure." The reciprocity law states that the intensity of the light that strikes a film multiplied by the exposure time equals the amount of exposure ($I \times t = E$). This law applies to most black-and-white films at exposure times from approximately 1/15 to 1/1000 second.

At exposure times outside this range, however, you will begin to see underexposure at the normally calculated exposure setting (a loss of effective film speed) or a change in contrast, or both. We refer to these phenomena as "long-exposure effects" and "short-exposure effects."

When you compensate for these effects with most black-and-white films by adjusting film exposure, you must also adjust the development time to produce the proper contrast. (See the table below.) However, T-MAX Professional Films do not require a development-time adjustment.

Long-Exposure Effects

Under low-light conditions, you may have to extend exposure times to a point of significant speed loss. The effect of this speed loss is partially offset by the wide exposure latitude of black-and-white films.

When you must increase the calculated exposure to compensate for long-exposure effects (see the tables below), use a larger lens opening, if possible. Extending the exposure time will result in additional speed loss or a change in contrast.

Short-Exposure Effects

Extremely short exposures produce essentially the same effect as long exposures: speed loss. You can also see an increased scattering of exposed silver halide grains, a smaller latent-image center, and a lower rate of development at the latent-image center.

These effects appear as lower contrast or a reduction in the highest-density areas of the negative. Exposures of 1/1000 second or shorter can cause this problem. Some films (e.g., KODAK PROFESSIONAL EKTAPAN Film), however, were designed to minimize the short-exposure effect.

Adjustments for Long and Short Exposures: Use the exposure and development adjustments in the following table for these black-and-white films:

KODAK PROFESSIONAL
 EKTAPAN Film
KODAK PLUS-X Pan Film
KODAK PLUS-X Pan
 Professional Film
KODAK TRI-X Pan Film
KODAK TRI-X Pan Professional Film
KODAK VERICHROME Pan Film

Exposure and Development Adjustments for Long and Short Exposures

If Calculated Exposure Time Is (Seconds)	Use This Lens-Aperture Adjustment	OR	This Adjusted Exposure Time (Seconds)	AND	This Development Adjustment
1/100,000*†	+ 1 stop		Adjust aperture		+ 20%
1/10,000*†	+ 1/2 stop		Adjust aperture		+ 15%
1/1000	None		None		+ 10%‡
1/100	None		None		None
1/10	None		None		None
1	+ 1 stop		2		– 10%
10	+ 2 stops		50		– 20%
100	+ 3 stops		1200		– 30%

* Not applicable to EKTAPAN Film.
† Not recommended for TRI-X Pan Professional Film/4164.
‡ EKTAPAN Film does not require an adjusted development time at 1/1000 second.

For T-MAX Professional Films,* use the exposure adjustments in the table below. For other films, see the Data Sheets.

If Calculated Exposure Time Is (Seconds)	T-MAX 100 Professional Film		T-MAX 400 Professional Film		T-MAX P3200 Professional Film	
	Use This Lens-Aperture Adjustment OR	This Adjusted Exposure Time (Seconds)	Use This Lens-Aperture Adjustment OR	This Adjusted Exposure Time (Seconds)	Use This Lens-Aperture Adjustment OR	This Adjusted Exposure Time (Seconds)
1/10,000	+ 1/3 stop	Adjust aperture	None	None	None	None
1/1000	None	None	None	None	None	None
1/100	None	None	None	None	None	None
1/10	None	None	None	None	None	None
1	+ 1/3 stop	Adjust aperture	+ 1/3 stop	Adjust aperture	None	None
10	+ 1/2 stop	15	+ 1/2 stop	15	+ 2/3 stop	15
100	+ 1 stop	200	+ 1 1/2 stops	300	+ 2 stops	400

*For T400 CN Film, no exposure compensation for reciprocity failure is necessary for exposures between 1/10,000 and 120 seconds. For critical applications, make tests under your conditions.

Average Adjustments for Most KODAK Black-and-White Films:

It may be difficult to use the tables on page 31 to estimate the adjusted times for calculated exposure times between 1 second and 100 seconds. The graph below will help you find the adjusted times for calculated exposure times between those given in the table.

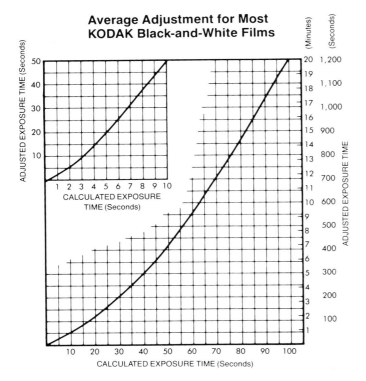

Average Adjustment for Most KODAK Black-and-White Films

IMAGE-STRUCTURE CHARACTERISTICS

If we contact-printed all negatives, we could think of images as perfectly smooth in texture and absolutely sharp in definition. However, almost all negatives are enlarged; and when you enlarge a photographic image, you can see a random pattern in the image areas where you expect to see uniform density. Also, edges and details are not perfectly sharp, even in the plane of best focus. These limitations are due to the physical structure of film emulsions.

The visual effect of unevenness in areas that should be uniform is called *graininess*. An objective measurement of graininess is called *granularity.*

The ability of a film to record fine detail is called *definition,* which is a composite effect of granularity, resolving power, and sharpness. The measurement of this characteristic of films is called *resolving power* or *resolution.* Resolution test targets are used to make this measurement.

Granularity

The densities in a black-and-white negative are composed of microscopic grains of metallic silver. Because the grains are placed randomly in the gelatin of the emulsion, clumping occurs and forms the familiar granular pattern that becomes increasingly visible as negatives are enlarged to greater degrees. As a rule, the faster the film, the greater its tendency towards graininess. KODAK T-MAX Professional Films, however, bend this rule. Because these films have KODAK T-GRAIN Emulsion, they have finer grain than conventional films of comparable speed. T-GRAIN Emulsion technology flattens silver-halide crystals from their normal pebble shape (see the illustration on page 38). The greater surface area of the crystal makes it more sensitive to light, so speed is increased without sacrificing fine grain.

KODAK Technical Pan Film

KODAK T-MAX 100 Professional Film

KODAK PLUS-X Pan Film

KODAK T-MAX 400 Professional Film

KODAK TRI-X Pan Film

KODAK T-MAX P3200 Professional Film (Exposed at EI 3200)

Granularity measurements yield numeric values that we use to place films in the graininess classifications included in the Data Sheets.

In addition to the inherent characteristics of the emulsion of a film, other factors affect the graininess of a negative.

The type of developer you use affects graininess. A fine-grain developer decreases graininess, usually with some loss of film speed. Overdevelopment, i.e., using an extended development time, a high temperature, or a highly active developer, increases graininess. (When overdevelopment produces high-contrast negatives, you can print them on a low-contrast paper to help reduce the appearance of graininess.)

If film is immersed in a processing solution that is at a temperature significantly different from the temperature of the film, reticulation may occur. Reticulation can also increase graininess.

High density caused by overexposure of a negative also increases graininess. Proper exposure and development almost always produce an optimum level of graininess. (Large, even-toned areas in the midtones of a photograph will appear more grainy than dark- or light-toned areas or areas that include fine detail.)

J. W. Fry

Contact print (above) made from a full-frame 35 mm negative on KODAK T-MAX 100 Professional Film. The photos at the left—sections of the image above—show the grain structure of several popular Kodak black-and-white films magnified 13X.

Resolving Power or Resolution

The resolving power or resolution of a film refers to its ability to reproduce fine detail. Resolving power is measured by photographing resolution targets or charts under specific test conditions. Resolution targets have several groups of parallel lines. The spaces between the lines are the same width as the lines. Each group of lines differs in size from adjacent groups and the next larger group by a mathematical factor such as the square root of 2 (1.414). The targets are photographed at a great reduction. After processing, the film is examined through a microscope to find the smallest group of lines that are discernible. This group of lines indicates the resolving power of the film—this measurement is expressed in lines per millimetre.

Resolving-power values depend on the contrast of the test target, the exposure, and—to a lesser degree—the development of the film. The resolving-power values given in the Data Sheets are the maximum values measured for normally exposed and processed film. Resolution decreases with under- and overexposure.

Resolution is usually measured with a high-contrast test target and a low-contrast test target. The lighting ratios for the targets are 1000:1 and 1.6:1, respectively. A film will resolve finer detail when the image contrast is higher. The resolving-power values for high- and low-contrast targets are given in the Data Sheets.

The maximum resolution that you can obtain in practical photography is limited by the resolution of the camera lens as well as the resolution of the film; it is lower than the resolution of the lens or the film alone. To predict the resolution of negatives, you can use the following formula:

$$\frac{1}{(R_S)^2} = \frac{1}{(R_F)^2} + \frac{1}{(R_L)^2}$$

R_S = Resolution of the system (lens + film)

R_F = Resolution of the film

R_L = Resolution of the lens

In practice, other factors such as camera movement, poor focus, haze, etc, also decrease maximum resolution.

Sharpness

The sharpness of a film is the subjective perception of good edge distinction between details in a photograph. However, the boundary between dark and light details is not a perfectly sharp line. The dark areas in a negative tend to bleed over into the light areas because of light scattering (or diffusion) within the emulsion. This effect varies with different types of emulsions, the thickness of the emulsion, and the thickness of the film base, as well as the anti-halation properties of the base and its backing.

Film manufacturers measure sharpness. The procedure is complex and beyond the scope of this book, but briefly, a sine-wave test pattern of varying frequencies is photographed. The test pattern recorded on the film is scanned by sensitive measuring equipment. Then the data are plotted graphically as modulation transfer function, and are analyzed to determine the sharpness classification.

Tips for Good Definition: To achieve good photographic definition, follow these suggestions:

- Keep your camera lenses clean and free of dust and fingerprints.

- Use a lens shade to keep stray light from striking the front of the lens. This will reduce flare to improve contrast and rendition of detail in the image.

- Focus carefully. With a view camera, check the focus at several locations on the ground glass with a magnifier.

- When you want sharp images of both near and distant objects in a scene, check the depth-of-field scale on your camera lens for the best focus setting and lens opening to use. Most lenses produce best definition at a lens opening about midway on the lens-opening scale.

- Hold your camera steady and squeeze the shutter release slowly. For maximum steadiness, place your camera on a tripod. Use the fastest shutter speed that the lighting conditions permit.

- Expose the film correctly; avoid overexposure, which produces negatives that are too dense. Excess density causes a loss of definition and an increase in graininess. Use the minimum exposure required to produce negatives that will yield prints with good shadow detail.

- Develop the film to a density range that will print well on a grade 2 paper with your enlarger with the degree of contrast that you like. Overdevelopment will make the highlights grainier and less sharp.

- You can sometimes enhance image sharpness by developing some films in certain dilute developers; these developers produce edge effects that make boundaries between objects appear sharper.

A typical resolving-power test target

- Use a clean, high-quality enlarger lens. The lower lens surface is especially prone to fingerprints; the top lens will collect dust.

- If definition is very important, print your negatives on a smooth-surface paper, such as a glossy or smooth-luster paper.

- Print your negatives on a grade of paper that will produce a print with good tone rendition and the proper degree of contrast.

- Use a grain focuser to focus the enlarger accurately. Be sure that your enlarger is free of vibration.

- Use the recommended safelight filter and bulb at the proper distance. Eliminate stray light to prevent fogging. (Fog will degrade the highlights, which can lower the apparent definition.)

FILM SPEEDS

You will normally get best results by using the film-speed number assigned to each film with cameras and meters marked for ISO, ASA, or DIN speeds or exposure indexes. These speed numbers are determined by a sensitometric procedure specified by the International Organization for Standardization and are based on the statistical average of a large number of scene-luminance measurements. ISO speeds may be arithmetic or logarithmic. Film-speed numbers indicate the relative sensitivity of films to light. For example, if all other factors in a system are equal, a film with a speed of 200 requires twice as much exposure as a film with a speed of 400.

Some cameras and meters are marked in logarithmic speeds, also known as DIN or ISO°/DIN speeds. An increase of one in logarithmic speed indicates a film that is one-third stop faster. For example, KODAK TRI-X Pan Film, with a logarithmic speed of 27°, is one-third stop faster than KODAK TRI-X Pan Professional Film, with a speed of 26°. In this book, we use a degree symbol after logarithmic film speeds to differentiate them from arithmetic film speeds. The following table gives equivalent speeds.

ISO (Arithmetic)/ISO° (Logarithmic) Film Speeds

ISO	ISO°	ISO	ISO°
6	9	320	26
8	10	400	27
10	11	500	28
12	12	640	29
16	13	800	30
20	14	1000	31
25	15	1250	32
32	16	1600	33
40	17	2000	34
50	18	2500	35
64	19	3200	36
80	20	4000	37
100	21	5000	38
125	22	6400	39
160	23	12,500	42
200	24	25,000	45
250	25		

Exposing film at its rated speed should usually lead to the minimum exposure required to produce good-quality negatives. However, exposure and development conditions that differ significantly from those used to determine the film speed can alter the *effective* film speed. Therefore, you may need to use a higher or lower speed number, or exposure index, to obtain correct exposure under your conditions. Films used for copying or technical applications, in which exposure and development conditions vary greatly, are often assigned an exposure index for trial exposures or tests instead of an ISO film speed. Consider exposure indexes as guides.

In the Data Sheets for most Kodak panchromatic films, only one speed number is given. For other films, such as T-MAX 100 and 400 Professional Films and Technical Pan Film, more than one speed is given. Set the film speed according to the developer you plan to use. For example, if you plan to develop T-MAX 100 Professional Film in KODAK T-MAX Developer or KODAK PROFESSIONAL Developer D-76, set the speed at EI 100. If you plan to use KODAK PROFESSIONAL MICRODOL-X Developer (undiluted), set the speed at EI 50. See the Data Sheets for the film speeds to use with other developers.

The speed numbers for infrared-sensitive films are starting-point recommendations because exposure meters are calibrated for visible radiation, and the images on infrared films are formed primarily by invisible radiation. Similar light levels may contain different amounts of infrared radiation. Whenever possible, make trial exposures to determine the proper exposure for your conditions.

Variable Film Speeds

T-MAX 100 Professional, T-MAX 400 Professional, T400 CN, PLUS-X Pan, PLUS-X Pan Professional, and TRI-X Pan Films can be rated at 1 stop faster than their given speeds without requiring push processing. See page 58 for more information.

EXPOSURE LATITUDE

Exposure latitude is the ability of a film to produce usable negatives in spite of under- or overexposure. In the early days of photography, latitude was very important because determining proper exposure was difficult (there were no meters to measure light) and the characteristic curves of films and plates "shouldered off" fairly quickly.

Today, with exposure meters that enable you to measure the subject luminance accurately, more accurate film-speed ratings, and the wide latitude of most continuous-tone black-and-white films, producing correctly exposed negatives is not difficult.

However, as we mentioned earlier, a number of factors contribute to the quality of negatives: proper density and contrast, graininess, definition, tone-reproduction characteristics, etc. Exposure affects all of these factors.

The bottom illustration on page 37 shows that most films have very little latitude for underexposure (about 1 stop maximum). However, *from a tone-reproduction standpoint only,* many stops of overexposure latitude are built into Kodak continuous-tone films made for pictorial photography. When developed to a contrast index of 0.40 to 0.56 (or 0.60 for T-MAX 400 Professional Film), these films have as many as 10 stops beyond the diffuse-highlight region where the straight-line portion of the characteristic curve continues without forming a shoulder.

However, because density increases in proportion to the amount of overexposure, printing times increase, definition can be adversely affected, and graininess increases. It's best not to use any more of the overexposure latitude than is necessary to obtain adequate shadow detail. Three stops of overexposure is a practical limit.

When the subject-luminance ratio is less than that of a full-scale subject (e.g., on overcast days), exposure latitude increases. In scenes with a high subject-luminance ratio, however, exposure latitude decreases. You can calculate exposure for these scenes by measuring two areas of the subject to obtain adequate shadow detail (see page 13). If you use the contrast-control method when you process the film, you will be able to produce a density range that is similar to that of a negative of a normal subject.

A photographer who exposes color transparency films must learn to control exposure to a fraction of a stop for maximum quality. If you exercise the same control in black-and-white photography, you will produce negatives that will print with maximum quality.

Fred Snyder

Low-contrast subject

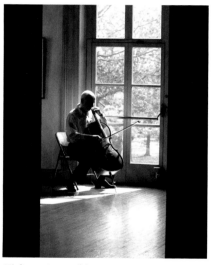

John Apostlos

High-contrast subject

Application	KODAK Sheet Film
Line Copy—extremely high contrast	KODALITH Ortho, Type 3 / 2556
Line Copy—very high contrast	Contrast Process Ortho / 4154
Continuous-Tone Copy	T-MAX 100 Professional / 4052 Commercial / 4127 Professional Copy / 4125
Direct Duplicate Negatives	B/W Duplicating SO-132 T-MAX 100 Professional / 4052 (processed in the KODAK T-MAX 100 Direct Positive Film Developing Outfit)
Transparencies from Negatives	Fine Grain Positive / 7302
Continuous-Tone— low speed	Technical Pan / 4415
Continuous-Tone— medium speed	T-MAX 100 Professional / 4052 EKTAPAN / 4162 PLUS-X Pan Professional / 4147
Continuous-Tone— high speed	T-MAX 400 Professional / 4053 TRI-X Pan Professional / 4164
Continuous-Tone— very high speed	T-MAX 400 Professional / 4053 (push processed) TRI-X Pan Professional / 4164 (push processed)
Special Sensitivity	High Speed Infrared / 4143

Application	KODAK Roll Film
Line Copy— extremely high contrast	KODALITH Ortho, Type 3 / 6556 Technical Pan (processed in the T-MAX 100 Direct Positive Film Developing Outfit for title slides) EKTAGRAPHIC HC Slide
Line Copy— high contrast	Technical Pan / 2415 and 6415 (processed in KODAK PROFESSIONAL Developer D-19)
Continuous-Tone Copy	T-MAX 100 Professional / 5052
Transparencies from Negatives	EASTMAN Fine Grain Release Positive / 5302
Continuous-Tone— low speed	Technical Pan / 2415 and 6415 (processed in KODAK PROFESSIONAL TECHNIDOL Liquid Developer)
Continuous-Tone— medium speed	T-MAX 100 Professional / 5052 and 6052 PLUS-X Pan PLUS-X Pan Professional VERICHROME Pan
Continuous-Tone— high speed	T-MAX 400 Professional / 5053 and 6053 TRI-X Pan TRI-X Pan Professional
Continuous-Tone— very high speed	T-MAX P3200 Professional / 5054 (exposed at EI 800 to 1600) T-MAX 400 Professional / 5053 and 6063 (push processed) TRI-X Pan Professional (push processed)
Continuous-Tone— extremely high speed	T-MAX P3200 Professional / 5054 (exposed at EI 2000 to 3200)
Continuous-Tone— ultrahigh speed	T-MAX P3200 Professional / 5054 (exposed at exposure indexes greater than 3200; see DS-14)
Special Sensitivity	High Speed Infrared / 2481

You can also use Technical Pan Film for copy work to produce continuous-tone originals or copy negatives, or you can use it with the KODAK T-MAX 100 Direct Positive Film Developing Outfit to produce slides from computer-generated graphs and line art or to create high-contrast title slides.

KODAK PROFESSIONAL Commercial Film/4127 is a blue-sensitive, moderately high-contrast film for copying continuous-tone originals when red and green sensitivity is unnecessary or unwanted.

In the past, faster films meant increased graininess, but the introduction of T-GRAIN Emulsion technology and T-MAX Professional Films has altered the relationship between speed and grain. Films with T-GRAIN Emulsions can have fine grain and high speed.

Kodak uses T-GRAIN Emulsion technology to manufacture T-MAX 100, 400, T400 CN, and P3200 Professional Films. All of these panchromatic films except T400 CN can be processed in standard developers. T-MAX Professional Films require smaller development-time adjustments than other films require for zone-system controls.

Any photographer who wants to create black-and-white photographs without working in a darkroom should try KODAK PROFESSIONAL T-MAX Black-and-White Film T400 CN. T400 CN is a 400-speed, multipurpose film designed for processing with color negative films in Process C-41. Black-and-white prints can be made on either color negative papers or black-and-white papers.

T-MAX 100 Professional Film's extremely high sharpness and extremely fine grain make it ideal for photographing detailed subjects when you need maximum image quality in outdoor or studio applications. It allows a very high degree of enlargement. This film can also produce copies of continuous-tone prints that are difficult to distinguish from the originals.

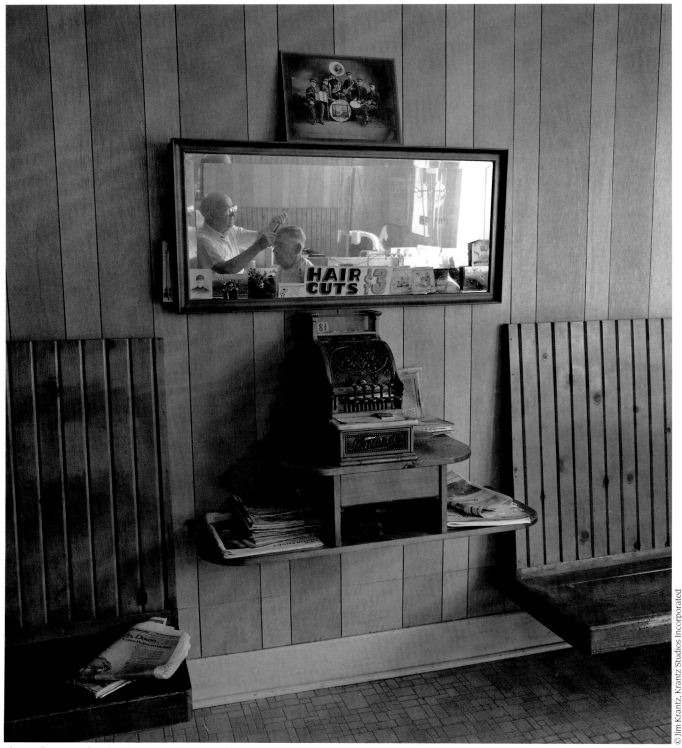

The medium speed and wide exposure latitude of KODAK T-MAX 100 Professional Film enable you to expose it under some ambient-light conditions indoors. Jim Krantz used T-MAX 100 Professional Film to capture the personality of this small-town barber shop.

If you process T-MAX 100 Professional Film with the T-MAX 100 Direct Positive Film Developing Outfit, you can produce high-quality slides from continuous-tone photographs, drawings, artwork, and radiographs. You can also use this film with the T-MAX Outfit to produce copy negatives from black-and-white negatives, to duplicate black-and-white slides, or to make black-and-white slides from color slides.

KODAK PROFESSIONAL EKTAPAN Film is a medium-speed panchromatic film for portraiture and close-up work with electronic flash. It is also an excellent choice for commercial, industrial, and scientific uses with daylight or tungsten light.

KODAK PLUS-X Pan Film and KODAK PLUS-X Pan Professional Film/6057 (PXP) are popular medium-speed panchromatic films that are good choices for general-purpose outdoor or studio photography. Their characteristic curve has a short toe and a long straight-line portion, which make them ideal for the high-flare conditions of many outdoor scenes. These films also feature very good tone-reproduction characteristics.

KODAK PLUS-X Pan Professional Film/2147/4147 has emulsion characteristics that are different from those of PLUS-X Pan Film and PLUS-X Pan Professional Film/6057. Although the grain is not quite as fine, this film allows almost the same degree of enlargement as PLUS-X Pan Film. The shape of the characteristic curve of PLUS-X Pan Professional Film/2147/4147 can be described as "all toe" in the exposure range

that is normally used. This makes it suitable for low-flare conditions (e.g., in the studio) and provides unusually good separation of highlight tones.

KODAK VERICHROME Pan Film is a medium-speed panchromatic film that features extremely fine grain. Its excellent gradation and wide exposure latitude make it a good choice for general applications.

KODAK TRI-X Pan Professional Film is a high-speed panchromatic film with excellent tone gradation and brilliant highlights. It is especially well suited to low-flare interior lighting or flash illumination. It is also useful for portraiture with low-contrast backlighting outdoors.

When an assignment requires a high-speed film, T-MAX 400 Professional Film is an excellent choice. You can use it to photograph subjects that require good depth of field and fast shutter speeds with maximum image quality for the film speed. It features finer grain than PLUS-X Pan Film and has more than three times the speed; it provides versatility and high quality. At its nominal speed of EI 400, it gives excellent results—better than those from other films of comparable speed. Because of its wide exposure latitude, you can rate it at EI 800 and still obtain excellent results with no increase in development time. You can mix exposures based on EI 400 and EI 800 on a single roll. With push processing in KODAK T-MAX Developer or T-MAX RS Developer and Replenisher, you can push it by as much as 3 stops (to EI 3200) and still obtain good-quality prints.

KODAK TRI-X Pan Film has higher

speed than TRI-X Pan Professional Film. It is most often used as a general-purpose film—it is fast enough for most existing-light photography, yet slow enough for exposure under normal daylight conditions. It features fine grain.

KODAK T-MAX P3200 Professional Film is a multispeed film that has great exposure latitude. This film combines high to ultrahigh speeds with finer grain than that of other fast black-and-white films. It is especially useful for very fast action, for dimly lighted scenes where you can't use flash, for subjects that require good depth of field combined with fast shutter speeds, and for hand-holding telephoto lenses for fast action or in dim light. Its nominal speed is EI 1000 when it is processed in T-MAX Developer or T-MAX RS Developer and Replenisher, or EI 800 when it is processed in other Kodak black-and-white developers. It is an excellent choice for applications that require exposure indexes of 3200 to 25,000.*

*To expose T-MAX P3200 Professional Film at speeds higher than EI 6400, it is critical that you make tests to determine if the results are appropriate for your needs. For best results when you expose the film at these speeds, use T-MAX Developer or T-MAX RS Developer and Replenisher.

High-Contrast Films

High-contrast films are almost always used for special applications.

For copying line drawings, text, or other high-contrast subjects, KODAK PROFESSIONAL KODALITH Ortho Film, Type 3, is an excellent choice. When developed in KODAK PROFESSIONAL KODALITH Super RT Developer (or another Kodak developer intended for KODALITH Films), this extremely high-contrast, orthochromatic film produces tones of essentially two densities—an extremely high density (black) and a low base-plus-fog density. You can also use KODALITH Ortho Film, Type 3, to produce masks to improve the reproduction of highlight detail when you make duplicate transparencies or dye-transfer prints.

KODAK PROFESSIONAL Contrast Process Ortho Film/4154 is a high-contrast orthochromatic film. Use it for copying black-and-white line originals or black printed or handwritten text on a white, blue, green, or yellow background with a copying setup similar to the one shown below.

When Technical Pan Film is processed in KODAK PROFESSIONAL Developer D-19, it is a high-contrast film. It has several advantages over KODALITH Ortho Film, Type 3: higher speed, extended red sensitivity for document copying, and greater resolving power and finer grain, which allow greater reductions in copying.

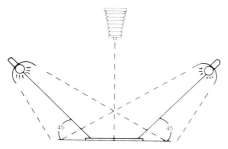

To obtain even lighting across a copyboard for copying photographs or artwork, aim the beams from the lamps as shown here.

Print from the original negative

Gordon Brown

Print from a duplicate negative

You can duplicate an original negative by exposing it directly onto a duplicating film, such as KODAK PROFESSIONAL B/W Duplicating Film SO-132.

44

the dark slides cannot be accidentally removed. Place the loaded film holder in an area away from the unloaded holders.

After you have loaded all the holders you need, place any unused film in the envelope, fold the end of the envelope closed, and return the envelope to its two-part box.

Loading Sheet-Film Hangers:
Before you load sheet-film hangers, make sure they are clean and dry, and be certain that you have everything ready for loading and processing. Open the hinged top of each hanger and stack the hangers within easy reach.

In total darkness (or under the recommended safelight conditions), remove your exposed film from the film holder or other lighttight container. To load a hanger, hold it in one hand or place it flat on the work surface. Pick up the first sheet of film with the emulsion facing you and insert it into the hanger by guiding the edges into the channels. Gently push the sheet all the way into the hanger until it reaches the bottom channel. Spring the hinged top back into place. After you load each hanger, place it in a clean, dry rack or empty tank.

Roll and 35 mm Films

Depending on the format you use, you will have to separate the film from its paper backing or remove it from its lighttight magazine.

Unwind roll films in total darkness (or under the recommended safelight conditions). Roll up the paper backing as you unwind the film. (For convenience, you can load the film onto a reel as you unwind the roll. See "Loading Film Reels," at the right.) When you reach the end of the roll, separate the film from the paper backing by removing or tearing the adhesive strip. You may notice a small spark as you remove or tear the strip; this spark will not fog the film. However, unrolling the film quickly in dry conditions can cause static sparks, which will fog the film. Be careful not to kink or buckle the film—kinking and buckling will cause crescent-shaped high-density marks.

In total darkness (or under the recommended safelight conditions),

Insert the film—emulsion side facing you—into a sheet-film hanger by guiding the edges into the channels.

Handle several hangers as a unit.

You can open 35 mm magazines by removing the flat end cap with a bottle opener.

To use a plastic "walk-in" reel, cut the end of the film square, and slide the end of the roll into the slot on the outside of the reel. Then rotate the flanges of the reel in opposite directions. The film will "walk" into the reel as you turn the flanges.

open 35 mm magazines by removing the end cap from the flat end of the magazine with a bottle opener or jar-lid opener (or a magazine opener). Remove the roll from the magazine and cut off the tongue of the film to make the end square. As you load film onto a film reel (see below), unroll it slowly and carefully from the spool to avoid producing static.

To unload film from reusable magazines and cassettes, see the manufacturer's instructions.

Loading Film Reels: Always load film onto clean, dry reels. Stainless-steel reels are almost always loaded from the center out with the emulsion side of the film facing in. Most stainless-steel reels have a clip in the center of the reel that holds the film. It is important to center the end of

the film in the reel; center the film by gently bending the edges of the film so they seat in the start of the spiral grooves—make sure that both edges are in the grooves. As you rotate the reel, gently bend the film so that the edges seat in the grooves. Be careful not to kink or buckle the film as you load it onto the reel.

Some plastic reels are loaded from the center out in the same way that stainless-steel reels are loaded. Other reels have a "walk-in" feature. To use a walk-in reel, slide the end of the roll into the slot on the outside of the reel, and rotate the flanges of the reel in opposite directions so that the film "walks" into the reel.

Long rolls of film are usually processed on special spiral reels. Follow the manufacturer's instructions for loading the film onto this type of reel.

Static Marks

When you subject a camera or film to friction, it may become positively or negatively charged with static electricity. Your film or camera then tries to return to a neutral state by transferring electrons to or from other objects. Sometimes this transfer occurs slowly without any adverse effects, but sometimes the charge builds up faster than it can safely dissipate. Then a sudden discharge produces heat, light, and ultraviolet radiation. The ultraviolet radiation forms a latent image on your film in the shape of the static discharge. You will notice these unwanted images on your processed negatives.

Although friction is the main cause of static charges, the separation of film surfaces as a roll is unwound rapidly can also cause static. As a rule, static is most troublesome when the relative humidity is low.

The branch-like markings you see occasionally on sheet-film negatives are caused by static discharge. They are characteristic of a negative charge that is discharged to a small point or object. Static markings can, however, take a number of other forms that are not so easily recognized. For example, diffuse spots with dark centers are produced when a charge builds up on the camera and then discharges to the film. A similar marking, called bar static, looks like a row of spots (often surrounded by fogged areas) that extend across the width of roll film. This type of marking can occur when you unwind a roll of film that has been tightly wound. Unrolling the backing paper from roll film and passing the film rapidly between your fingers can produce a line of closely spaced bead-like spots down the center of the roll. You may cause an irregular blotchy pattern if you unwind a roll of slightly damp or tacky film. This blotchy pattern is characteristic of moisture static.

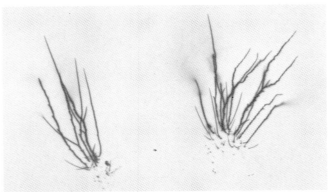

These branch-like static marks are caused by a discharge from a small negatively charged point or object.

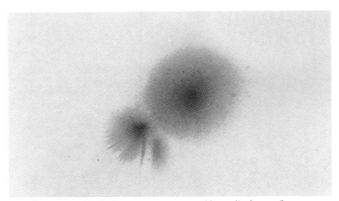

Circular spots with dark centers are caused by a discharge from a nearby object to positively charged film.

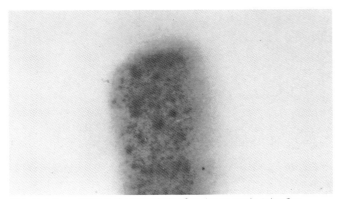

This blotchy pattern is characteristic of moisture static. It is often caused by unwinding a damp or tacky roll of film.

During manufacturing and packaging, Kodak takes every possible precaution to avoid the buildup of static charges on sensitized products. The following precautions will help you avoid problems caused by static:

- Avoid handling film with sudden movements that might cause friction.

- If possible, keep the relative humidity at 40 to 60 percent in the areas where you load and unload film.

- Do not wind or unwind roll films rapidly; don't wind rolls too tightly.

- Move plastic dark slides in sheet-film holders slowly; don't withdraw or replace the slides quickly. When you remove the slide, do not place it under your arm and then withdraw it quickly to reinsert it into the film holder. (This can induce a static charge in the slide that may discharge to the film.)

- Remove the backing paper from roll film carefully. Do not pass the film between your fingers to unroll it.

© Don Getsug

The speed and excellent tone reproduction of KODAK TRI-X Pan Film have made it a long-time favorite of photojournalists.

Film Processing

Small numbers of rolls are generally processed on spiral reels in small tanks singly or in batches, depending on the tank size. Bigger batches are usually processed in larger tanks such as those used for sheet films. You can process small amounts of sheet film in trays, and larger amounts in large tanks. The following information applies to processing in trays or tanks.

SAFELIGHTS

Recommended safelight filters for blue-sensitive and orthochromatic films are given in the Data Sheets and in the instructions packaged with the film. Nearly all processing of panchromatic films is done in total darkness. However, some experienced technicians check the progress of development of some films halfway through the development time under a safelight equipped with a KODAK PROFESSIONAL 3 Safelight Filter (dark green) and a 15-watt bulb placed 4 feet (1.2 metres) from the film. At this point, you can inspect the film *for a few seconds only*. If the film is overexposed, shorten the development time. Near the end of the development time, you can inspect it again. If it is badly underexposed, extend the development time to increase film density. It takes experience to recognize the degree of development under these conditions.

Notes: *Do not* develop T-MAX Professional Films by inspection.

T400 CN is intended only for Process C-41 with color negative chemicals.

DEVELOPMENT

Selecting a Developer

Several developers are suitable for use with most films. Your choice will depend on your needs and preferences. The table on page 53 provides useful information on a variety of developers that you can choose from. The Kodak developers recommended for each film are listed in the Data Sheets (pages DS-2 through DS-26); the Data Sheets also include development times for each developer. These times are average times intended to produce continuous-tone negatives with a contrast index of 0.56 to 0.60 and a density range from approximately 1.05 to 1.10 for full-scale subjects photographed with a lens of moderate flare. This type of negative usually prints well on a grade 2 paper with a diffusion enlarger with incandescent illumination. However, as explained earlier, your film may require a shorter or longer development time to produce the best results for your application and equipment; the ringaround test described on page 21 provides a method of determining the best development time for your application.

Temperature Control

Control of developer temperature is critical in maintaining uniform negative quality. A deviation of plus or minus 1°F (0.5°C) can change the characteristics of a negative unless you adjust the development time to compensate for the decrease or increase in temperature.

You can successfully process most black-and-white films at temperatures ranging from 65 to 75°F (18 to 24°C) if you use the appropriate development time for the temperature you choose. The primary recommended temperature for developing most films in T-MAX Developer or T-MAX RS Developer and Replenisher is 75°F (24°C). With T-MAX P3200 Professional Film, the recommended range is 70 to 85°F (21 to 29°C). The primary recommended temperature for other developers is 68°F (20°C).

Note: The primary recommended temperatures for processing black-and-white films are *starting points*. Chose the most convenient temperature for your application, but be sure to use the appropriate development time for the temperature you select, and control the temperature carefully.

It is usually easier to maintain a solution temperature that is at or near room temperature. Also, if you process at higher temperatures, you may have to use short development times that can lead to nonuniformity in the higher densities of a negative, particularly with tank development.

Immersion of film in successive baths of widely varying temperatures may create an effect known as reticulation, a wrinkling of the gelatin coating. Keep the temperature of all solutions and, if possible, the wash water close to the developer temperature.

KODAK Film Developers—Major Properties and Uses

KODAK Developer or Developer and Replenisher	General Characteristics	Type of Film Usually Developed	Type of Development Usually Used	Availability		
				Packaged Liquid Concentrate	Packaged Powder	Replenisher
T-MAX	Normal contrast, higher speed, average graini-ness; good for push processing	Continuous-tone 35 mm and roll	Small tank, large tank*; rotary-tube processors	X		
T-MAX RS†	Normal contrast, higher speed, average graini-ness; good for push processing	Continuous-tone 35 mm, roll, and sheet	Small tank, large tank, tray; rotary-tube, rack-and-tank processors	X		X
D-76‡	Normal contrast, normal speed, average graininess	Continuous-tone 35 mm, roll, and sheet	Small tank, large tank, tray; rotary-tube, rack-and-tank processors		X	X
HC-110	Normal contrast, normal speed, average graininess	Continuous-tone 35 mm, roll, and sheet	Small tank, large tank, tray; rotary-tube processors	X		X
XTOL§	Contrast index similar to other developers; features fine grain and high sharpness	Continuous-tone 35 mm, roll, and sheet	Small tank, large tank, tray; rotary-tube, rack-and-tank processors		X	X
MICRODOL-XⅡ	Slightly finer-than-average grain; produces some loss in effective film speed	Continuous-tone 35 mm and roll	Small tank, large tank	X	X	X
DK-50	Normal contrast, normal speed, average to slightly higher-than-average graininess	Continuous-tone 35 mm, roll, and sheet	Small tank, large tank, tray		X	X
D-19	Higher-than-nor-mal contrast and speed,¶ higher-than-average graininess	Instrumentation films, scientific plates	Large tank, tray		X	
D-11	Higher-than-nor-mal contrast and speed,¶ higher-than-average graininess	Continuous-tone and process films and plates	Large tank, tray		X	
D-8	Much higher-than normal contrast, speed, grain	Continuous-tone and process films and plates	Tray		X	
TECHNIDOL Liquid	Slightly finer-than-average grain; produces some loss in effective film speed	All formats of Technical Pan Film	Small tank, tray	X		

* If you use T-MAX Developer in a large tank, use time compensation. For information on time compensation,
 see KODAK Publication No. J-86, *KODAK T-MAX Developers*.
†Use the mixed solution as a working tank solution or a replenisher.
‡For greater sharpness, you can use this developer diluted 1:1. Using the diluted developer requires longer development times, which result
 in a slight increase in graininess.
§When using full-strength solution, use at least 150 mL of developer per roll. With 1:1 dilution, use 200 mL per roll;
 with 1:2 dilution, use 250 mL per roll; with 1:3 dilution, use 350 mL per roll.
Ⅱ For greater sharpness, you can use this developer diluted 1:3. Using the diluted developer requires longer development times,
 which result in increases in graininess and speed.
¶For its normal high-contrast use.

KODAK T-MAX 400 Professional Film provides flexibility in action and sports photography. You can make exposures at EI 400 and EI 800 on the same roll and process the film normally.

When you process small amounts of film, you can adjust the temperature of the developer to the correct value by placing the tray or tank in a bath of tempered water at the correct temperature and maintaining the temperature of the water bath with an ordinary mixing faucet. With this arrangement, place a thermometer near the water intake and monitor the temperature; varying loads on the hot- and cold-water supply lines may change the temperature of the bath. Water baths are especially useful for developing in small metal tanks, which transmit heat readily.

To process large amounts of film, you can use a water bath in which the water temperature is controlled automatically by a mixing valve or by an immersion heater equipped with a circulating pump and temperature-sensing device. These controls are available from suppliers of processing equipment. Sink units equipped with a temperature-control system and a vacuum breaker are also available.

Developer Replenishment

To maintain uniform negative quality when you process large amounts of film in tanks, you must replenish the developer. An average replenishment rate for black-and-white sheet film is 1 fluid ounce (30 mL) of replenisher for every 8 x 10-inch sheet (80 square inches) or equivalent processed; check your replenisher instructions. With a brief draining period between the developer and the stop bath, this rate is sufficient to compensate for normal carry-out of developer from the tank (as well as chemical depletion). However, if much more of the solution is lost in processing than is replaced by replenishment, you must make up the loss by adding fresh working-strength developer.

Because no single ratio of replenisher to area of film is correct for all situations, you may need to adjust the replenishment rate if your negatives become too thin or too dense over a period of time. A more accurate method of maintaining developer

activity is to monitor the process with KODAK PROFESSIONAL Black-and-White Film Process Control Strips and adjust replenishment according to the density readings of the strips.

AGITATION

The purpose of agitation is to remove the by-products of development from the surface of the emulsion so that fresh developer can act on the silver halides. Because agitation affects the rate of development, particularly in the high-density areas, consistent negative quality requires uniform agitation over the whole surface of the film and a similar degree of agitation for each batch of film.

Agitation should always consist of irregular or random movements that will not cause currents of solution to flow over the film constantly in one direction. Such currents increase agitation, and therefore density, along their paths.

Agitation in Small Tanks

The times given in the Data Sheets for small-tank development are based on the following agitation procedure:

1. Fill the tank with developer.

2. In the dark, smoothly immerse the loaded reel in the solution.

3. Attach the top to the tank. Firmly tap the bottom of the tank against the work surface from a height of approximately 1 inch (2.5 cm) to dislodge air bubbles.

The recommended method of agitation for an invertible tank.

The recommended method of agitation for a noninvertible tank.

4. Provide initial agitation of up to 5 cycles, depending on your results. Use 5 to 7 inversions in 5 seconds for T-MAX Professional Films. With an invertible tank, one cycle consists of rotating the tank upside down and then back to the upright position. With a noninvertible tank, one cycle consists of sliding the tank back and forth over a 10-inch (25.4 cm) distance. Steps 2 through 4 will take from 7 to 20 seconds, depending on the type of tank.

5. Let the tank sit for the remainder of the first 30 seconds.

6. After 30 seconds, start 5-second agitation cycles at 30-second intervals. These agitation cycles should consist of 2 to 5 cycles, depending on the contrast you need and individual technique.

If you are using the water-bath method of temperature control with a small metal tank, place the tank back in the water bath between agitation cycles.

Agitating Short Roll Films in a Large Tank

You can process several short rolls (5 feet [1.5 metres] or less) in a large tank. Wind each roll onto a spiral reel. Load the reels on a rack, in a basket, or on a spindle, and place the rack, basket, or spindle in the tank (typically a 1-gallon [3.8-litre] tank or a 3½-gallon [13-litre] tank). Many racks can hold up to 30 rolls of 35 mm film or 18 rolls of 120-size film. Use the following agitation procedure:

1. Start the timer. Lower the rack, basket, or spindle into the developer, and tap it sharply against the tank to dislodge air bubbles.

2. Agitate the film continuously for the first 15 to 30 seconds by raising and lowering the rack, basket, or spindle about ½ inch (1.3 cm). Be sure to keep the reels in the solution. *Do not* agitate the rack, basket, or spindle for the rest of the first minute.

3. Agitate once each minute by lifting the rack, basket, or spindle completely out of the developer, tilting it approximately 30 degrees to drain for 5 to 10 seconds, and then reimmersing it. Alternate the direction of tilting the rack, basket, or spindle.

Agitating Sheet Film in a Tray

To process an individual sheet, slide the film smoothly into the developer and rock the tray immediately to make sure the film is covered with solution. To agitate, first raise the left side of the tray about ¾ inch (1.9 cm), lower it smoothly, and then immediately raise and lower the side closest to you. Next, raise and lower the right-hand side, then the near side again. This agitation cycle takes about 8 seconds. Agitate continuously throughout the development time.

To process 2 to 6 sheets together, follow the procedure below, which includes a presoak step. Presoaking will prevent the sheets from sticking together and will promote even development.

1. Fill a tray with water that is at the same temperature as the developer.

2. Immerse the sheets one at a time, emulsion side up, in the tray of water. Make sure that each sheet is covered with water before inserting the next one. Agitate by moving the bottom sheet to the top of the stack every few seconds, and go through the stack twice. Be careful that the corners of the sheet you are handling do not scratch the sheet under it.

3. Take the bottom sheet out of the tray of water, drain it for a few seconds, and place it in the developer emulsion side up. Make sure that the sheet is covered with developer, and transfer the rest of the sheets to the developer in the same way. Interleave the stack, from bottom to top, until development is complete.

When you use interleaving agitation during tray processing, it is important to go through the stack of film completely. Rotate the first sheet in the developer 180° from the rest of the stack so that the code notch is at the opposite end. This identifies it as the first sheet in the solution. Be sure that it is the first sheet you remove from the solution.

Note: When you use interleaving agitation, it is important to go through the stack of sheets completely. Rotate the first sheet in the developer 180 degrees from the rest of the stack so that the notch is at the opposite end. This identifies it as the first sheet; be sure that it is the first sheet you remove from each solution.

4. At the end of the development time, transfer the sheets to the stop bath one at a time. To avoid contaminating the developer with stop bath, use one hand for lifting the sheets from the developer and the other hand for placing them in the stop bath.

Agitating Sheet Film in a Large Tank

Separate the film hangers by at least 1/2 inch (1.3 cm) to ensure good circulation of the chemicals. When you process films of different sizes together, such as 8 x 10-inch and 4 x 5-inch sheets, in the same tank, separate adjacent hangers that contain different-size sheets with a hanger loaded with an 8 x 10-inch sheet of acetate or scrap film to avoid uneven development of the larger sheets. This unevenness is

caused by turbulence around the central frame of the multiple-film hanger during agitation.

To agitate a single sheet of film or a batch of sheet films in hangers in a tank, follow this procedure:

1. Lower the hangers as a unit into the developer. Tap the hangers sharply against the rim of the tank two or three times to dislodge air bubbles.
2. Allow the hangers to remain undisturbed for the remainder of the first minute.
3. Lift all the hangers out of the solution and tilt them almost 90 degrees to the left. Reimmerse the hangers, lift them out again, and then tilt them almost 90 degrees to the right.
4. Check to see that the films are separated, and then reimmerse them.
5. Repeat this agitation cycle once every minute during the development time.

Note: Each agitation cycle should take about 6 seconds. When you process large sheets of film (e.g., 8 x 10 inches), be careful not to dislodge them from the hangers by lifting them from the solution too quickly.

Agitating Long Rolls on Spiral Reels

To process long rolls on spiral reels, use the agitation procedure given below. Too little agitation causes mottle and uneven development. Too much agitation (pumping the reel in and out of the developer) may produce streaks on the film across from the spokes of the reel. If you turn the reel more frequently than recommended, long streaks may form across the length of the film.

1. Lower the reel into the developer and vigorously turn it one-half to one revolution.
2. Raise and lower the reel approximately 1/2 inch (1.3 cm) continuously for the first 15 seconds; keep the reel in the solution. As you lower the reel, tap it against the bottom of the tank to dislodge air bubbles.
3. Once every minute, lift the reel out of the developer and tilt it 30 degrees to drain it for about 7 seconds.
4. Return the reel to the developer and vigorously turn it one-half to one revolution. Alternate the direction of turning the reel for each one-minute cycle.

Lift all the hangers out of the solution and tilt them.

Gaseous-Burst Agitation for Tank Development

You can use this form of agitation with many films and processing systems. It is a reasonably economical system to install and operate, and because it is automatic, it does not require the full-time attention of an operator.

Gaseous-burst agitation consists of releasing bursts of air or nitrogen at controlled intervals through many small holes in a distributor at the bottom of the processing tank. The large number of bubbles formed and the random nature of their path to the surface of the solution provide effective agitation across the surface of films hanging vertically in a tank. The gas is released in bursts to avoid constant flow patterns that would cause uneven development.

STOP BATH

The primary function of an acid rinse or stop bath is to stop development. It also serves other useful purposes in processing film. An acid stop bath removes the calcium scum that can form on the surface of film during development, and it prevents excessive swelling of the gelatin coating. By delivering the films into the fixer in an acid condition, the stop bath not only preserves the acidity and the hardening properties of the fixer, but also prevents the formation of alum scum and sludge.

Because an acetic-acid stop bath is colorless even after a period of use, you can determine its condition only by testing the acidity. To avoid the necessity for testing, you can use KODAK PROFESSIONAL Indicator Stop Bath. This yellow liquid turns a purplish blue to signal when the bath needs changing. You can easily see the color of the solution in an open tray. If you are using a dark-colored tank, you'll have to remove a sample of the solution occasionally to check its color.

FIXING

The fixer (also called hypo) removes the unexposed, undeveloped silver halide from the emulsion. The products of fixing are complex silver compounds. As more film is fixed in the solution, the concentration of these compounds increases. When the concentration reaches a certain critical level, some relatively insoluble compounds are formed; these compounds cannot be removed from film by washing. If residual silver compounds remain in the film, they eventually decompose and form the yellow stain often seen on negatives that have been stored for a considerable time. For this reason, you should test your fixing bath at intervals by following the procedure given on page 60.

Your fixer will be exhausted more rapidly with T-MAX Professional Films than with other films. If your T-MAX Film negatives show a magenta (pink) stain after fixing, your fixer may be near exhaustion or you may not have used a long enough fixing time. If the stain is slight, it will not have an adverse effect. If it is pronounced and irregular over the film, refix the film in fresh fixer.

Fixing Time

As a rule, films are properly fixed after immersion for twice the time it takes for the milky appearance in the film to clear completely. Note that the clearing time varies considerably with different types of emulsions and with the condition of the fixer. When the clearing time is twice as long as it was for the same film in fresh fixer, replace the fixing bath. Regardless of the clearing time, discard all fixing baths after one month of use. In tray processing, agitate films frequently during fixing to prevent them from sticking together or floating on the surface of the solution. In tank processing, agitate the films occasionally, and keep them separated.

The fixing times given in the instructions for Kodak films include a safety factor to compensate for the decrease in fixer activity that occurs after use. Do not exceed the recommended time, because the density of the silver image may be reduced, particularly in freshly mixed ammonium thiosulfate baths such as KODAK PROFESSIONAL Rapid Fixer.

WASHING

To prevent staining and possible deterioration of the silver image by residual chemicals, wash all negatives thoroughly. Washing negatives for 30 minutes in a tray or a tank with a complete change of water every 5 minutes is sufficient for most films.

You can wash small batches of negatives in a tray, but avoid excessive turbulence; rapidly moving films may scratch one another. The KODAK PROFESSIONAL Automatic Tray Siphon converts a tray into an efficient film or print washer that changes the water without the turbulence that can cause damage. Wash large batches of negatives in film hangers suspended in a tank. To conserve water, do not wash negatives much longer than 30 minutes, and do not use a tank much larger than that needed to accommodate the size or number of films.

You can save water and time by using KODAK PROFESSIONAL Hypo Clearing Agent. Bathe film in the Hypo Clearing Agent solution for 1 to 2 minutes with moderate agitation. (Using a 30-second water rinse before treatment will extend the capacity of the Hypo Clearing Agent solution.) Then wash the film for 5 minutes in running water with a flow rate that provides at least one complete change of water in that time.

Note: If residue appears frequently on your film after washing, you may want to install filtering equipment on the wash-water line.

If you hang film up to dry with water droplets on it, water spots and water marks are liable to form. You can prevent spots as follows:

- When you remove film from the wash water, carefully wipe the film surface with a damp chamois or a damp viscose sponge.

OR

- Bathe the film in diluted KODAK PROFESSIONAL PHOTO-FLO Solution for 30 seconds and hang it up to dry. Follow the directions carefully; using the correct dilution of PHOTO-FLO Solution is important.

DRYING

Most films air-dry within an hour at normal room temperature and relative humidity. To accelerate drying, use a heated cabinet or a current of warm air. Avoid excessive heat; a temperature of about 100°F (38°C) is suitable.

In a properly designed film-drying cabinet, the incoming air is filtered to remove dust and is then drawn out by an exhaust fan. The drying time in a cabinet depends on the relative humidity of the air more than the temperature. Under humid conditions, use a drying cabinet equipped with a refrigeration-type dehumidifier to shorten the drying time. If you hang films up to air-dry, choose a location with little or no traffic that can raise dust. Dust particles embedded in the gelatin coating are almost impossible to remove.

PUSH PROCESSING

When you push process films, you attempt to compensate for underexposure by developing the film for a longer time. The longer development time increases the density of midtones and highlights in the negatives. Most developers do not restore shadow detail lost through underexposure. However, T-MAX Developer and T-MAX RS Developer and Replenisher can actually enhance shadow detail.

Many photographers push process film whenever they expose it at a speed higher than its rated speed. Push processing is not always necessary; when you expose T-MAX 100 Professional Film at EI 200, PLUS-X Pan and PLUS-X Pan Professional Films at EI 250, or T-MAX 400 Professional, T400 CN, and TRI-X Pan Films at EI 800 (all 1 stop faster than their rated speed), it is recommended that you develop them for the normal time. The underexposure latitude of these films is wide enough to give you good results with finer grain than you would get with push processing.

Although you can use several Kodak developers for push processing, T-MAX Developer or T-MAX RS Developer and Replenisher give best results for most applications. These developers enhance shadow detail to provide better tone reproduction and keep graininess to a minimum.

Note that T400 CN cannot be processed in conventional black-and-white developers. T400 CN does produce acceptable negatives from exposure indexes as high as 3200 when push processed in Process C-41. Check with your photolab to ensure that it offers this service.

Push processing does have disadvantages. Compared to a film exposed at its normal speed and developed normally, a push processed film will yield negatives with less shadow detail and more graininess. As you rate the film speed higher and push development further, you lose more shadow detail and increase graininess. When the film has been exposed under contrasty lighting conditions, push processing may yield negatives that are difficult to print. If shadow detail is important, avoid pushing films such as T-MAX 400 Professional, T400 CN, and TRI-X Pan Films by more than 1 or 2 stops.

These disadvantages are often far outweighed by the benefit—being able to record images under adverse lighting conditions. Make tests to determine which pushed film speed gives you the best results.

REVERSAL PROCESSING

You can use the KODAK T-MAX 100 Direct Positive Film Developing Outfit to produce positive black-and-white slides from KODAK T-MAX 100 Professional Film and KODAK PROFESSIONAL Technical Pan Film.

The T-MAX Outfit contains a first developer, a bleach, a clearing bath, and a redeveloper. A fixer, which is not included with the outfit, must also be used. You can process film in small tanks, large tanks, or rotary-tube processors with these chemicals.

Use the outfit with T-MAX 100 Professional Film to produce high-quality slides from continuous-tone photographs, drawings, artwork, and radiographs. You can also use the outfit with T-MAX 100 Professional Film to produce copy negatives from black-and-white negatives, to duplicate black-and-white slides, or to make black-and-white slides from color slides. For normal-contrast reversal applications, expose T-MAX 100 Professional Film at EI 50; you can adjust the contrast by modifying the first-developer solution (see the instructions packaged with the outfit).

Use the T-MAX 100 Direct Positive Film Developing Outfit with Technical Pan Film to produce high-quality slides of computer-generated graphics and line art or to create high-contrast title slides. For reversal applications, expose Technical Pan Film at EI 64.

For more information on reversal processing, see KODAK Publication No. J-87, *KODAK T-MAX 100 Direct Positive Film Developing Outfit,* or the instructions packaged with the outfit.

PROCESSING FOR IMAGE STABILITY

Following the processing procedures outlined previously should yield negatives that will have an acceptably long life for most purposes. However, some applications, such as making photographic business records and producing photographs for museum archives, may call for very long storage or keeping times. For maximum image stability, you must process and store film according to specific procedures. Measure accurately when you mix chemical solutions, and avoid contamination of one solution with another. Only testing of negatives will prove how effectively your processing removed hypo and residual silver compounds from the film.

Processing Steps

Maintain a uniform temperature throughout processing.

1. Develop the film as recommended in the Data Sheet or in the instructions packaged with the film.
2. Rinse the film in an acid stop bath, such as KODAK PROFESSIONAL Indicator Stop Bath, for 30 seconds with continuous agitation.
3. For small amounts of film, use a single fresh fixing bath for the recommended time and with proper agitation. For large amounts of film, begin with two fresh fixing baths. Place the film in the first bath for half the recommended fixing time and in the second bath for the other half. Agitate the film as recommended. Before the first bath is exhausted (see the table below), discard it. Replace the first bath with the second bath. Replace the second bath with a fresh bath. If you are fixing several sheets of film in a tank, use film hangers to assure separation of the sheets.
4. Wash the film in running water for 30 minutes.
5. Rinse the film in KODAK PROFESSIONAL PHOTO-FLO Solution and hang it up to dry in a clean, dust-free environment, where the temperature is 70 to 80°F (21 to 27°C) with a relative humidity of about 70 percent.

Fixing Bath	Approximate Useful Capacities Per Gallon (Litre) in a Tray or Tank		
	135-36 Rolls	120 Rolls	8 x 10-inch Sheets
KODAK PROFESSIONAL Fixer	100 (26)	67 (17)	100 (26)
KODAK PROFESSIONAL POLYMAX T Fixer (1:3)	100 (26)	67 (17)	100 (26)
KODAFIX Solution (1:3)	120 (32)	80 (20)	120 (32)
KODAK PROFESSIONAL Rapid Fixer (1:3) (with hardener)	120 (32)	80 (20)	120 (32)

Bill Frakes/Miami Herald

The photographer exposed KODAK T-MAX P3200 Professional Film at EI 25,000 to record this scene in Miami in January 1989.

Testing for Excess Silver Compounds in Negatives

An overworked fixing bath contains complex silver thiosulfate compounds that are retained by the films; washing cannot completely remove them. These compounds lead to stains that may not become evident for a time. Extremely small amounts of silver compounds can cause an overall yellow stain on negatives, and no simple quantitative method can detect such small amounts. However, you can simulate the stain that might become visible in time by performing the following test:

1. Dilute 1 part of Residual Silver Test Solution ST-1 (see the formula below) with 9 parts of water. Replace this working solution weekly.

2. Place a drop of the working solution on an unexposed part of the emulsion side of a processed negative.

3. After 2 or 3 minutes, remove the solution with clean white blotter paper or absorbent tissue.

Any yellowing of the test spot, other than a barely visible cream tint, indicates the presence of silver compounds. If the test is positive, you can remove residual silver by refixing the negative in fresh fixer and rewashing for the recommended time.

Residual Silver Test Solution ST-1

Water 100 millilitres
Sodium Sulfide
(anhydrous)........................... 2 grams
You can store this stock solution in a small stoppered bottle for up to 3 months.

Testing Fixer for Effectiveness

Discard your fixer when film takes twice as long to clear as it does in fresh fixer. Here's a test you can perform in room light:

1. Place a piece of unprocessed film (of the same type you plan to process) in water for 1 minute; then place it in fresh fixer at the same temperature as the water. Note how long it takes for the milkiness to disappear from the film in the fixer.

2. Repeat this procedure to test your fixing bath; this fixer should be at the same temperature as the fresh fixer in step 1. Note the time it takes for the film to clear. If this time is twice the clearing time required in fresh fixer (or longer), replace your fixing bath with fresh fixer.

Testing Films for Residual Fixer after Washing

You can determine the residual fixer content of films accurately only by testing the processed film. One procedure is described in ANSI PH4.8-1985, *Determination and Measurement of Residual Thiosulfate and Other Chemicals in Films, Plates, and Papers*. Fixer limits are given in ANSI IT9.1-1989, *Specifications for Stability, Imaging Media (Film), Silver-Gelatin Type*.

You can make a fairly accurate estimate of residual silver by following the procedure given in the *KODAK Black-and-White Darkroom DATAGUIDE*, Publication R-20.

MORE INFORMATION

The following publications offer additional information on the subjects discussed in this book.

Kodak books, on a wide range of creative and technical photographic topics for both amateurs and professionals, are available from your photo dealer or contact:

**Silver Pixel Press®,
Division of The Saunders Group
21 Jet View Drive
Rochester, NY 14624 USA
Fax: (716) 328-5078**

KODAK Black-and-White Darkroom DATAGUIDE R-20

KODAK Gray Cards R-27

KODAK Professional Photoguide
 R-28

Advanced Black-and-White Photography KW-19

Black-and-White Darkroom Techniques KW-15

Basic Developing & Printing in Black and White AJ-2

Basic Developing, Printing, Enlarging in Color AE-13

KODAK Color Darkroom DATAGUIDE
 R-19

Kodak publications can be ordered directly from Kodak through the order form in the *KODAK Index to Photographic Information*, KODAK Publication No. L-1. To obtain a copy of L-1, send your request with $1 to Eastman Kodak Company, Department 412L, 343 State Street, Rochester, New York 14650 or visit the Kodak Web site via the Internet at http://www.kodak.com.

Data Sheets

KODAK PROFESSIONAL Black-and-White Films

These Data Sheets contain technical information on the Kodak black-and-white films listed below. Each sheet also contains a brief description of appropriate applications for the film.

The sensitometric curves and data in this publication represent product tested under the conditions of exposure and processing specified. They are representative of production coatings, and therefore do not apply directly to a particular box or roll of film. They do not represent standards or specifications that must be met by Eastman Kodak Company. The company reserves the right to change and improve product characteristics at any time.

Because recommendations may change, whenever these Data Sheets do not agree with the instructions packaged with the film, follow the film instructions. (The instructions in the film package are updated more frequently.)

KODAK PROFESSIONAL Commercial Film / 4127

KODAK PROFESSIONAL Commercial Film is a medium-speed blue-sensitive film with moderately high contrast. Use it for copying continuous-tone originals when red and green sensitivity is unnecessary or unwanted. Because of its blue sensitivity, you can use a red safelight when you process this film, which allows development by inspection.

Size Available:
Sheets (on ESTAR Thick Base)

Emulsion Characteristics:

Spectral Sensitivity—Blue

Grain—Very fine

Resolving Power—
Low-Contrast Test Object:
 40 lines/mm
High-Contrast Test Object:
 100 lines/mm (High)

Speeds:
Daylight—EI 50/18°
Tungsten or Quartz-Halogen—EI 8/10°
Pulsed-Xenon Arc—EI 12/12°

These exposure indexes are provided primarily as indicators of the relative speed of this film compared with other photographic materials. Use the exposure indexes for daylight, tungsten, or quartz-halogen illumination with exposure meters to establish trial exposures. The pulsed-xenon-arc value indicates the relative speed of this film to pulsed-xenon illumination measured with a light integrator.

Adjustments for Long and Short Exposures: Compensate for the reciprocity characteristics of this film by adjusting your exposure and development time as indicated in the table below:

If Calculated Exposure Time Is (Seconds)	Use This Lens-Aperture Adjustment	OR	This Adjusted Exposure Time (Seconds)	AND	This Development Adjustment
1/100	None		None		+ 10%
1/25	None		None		None
1/10	None		None		− 10%
1	None		None		− 20%
10	+ 1/2 stop		15		− 30%
100	+ 1 stop		300		− 40%

Darkroom Recommendations: Use a KODAK PROFESSIONAL 1 Safelight Filter (red) in a suitable safelight lamp with a 15-watt bulb. Keep the safelight at least 4 feet (1.2 metres) from the film.

Development: The development times in the table below are based on film used for copying or general applications, at an exposure time of 1/25 second.

KODAK PROFESSIONAL Developer	Development Time (Minutes)				
	Tray* or Large Tank†				
	65°F (18°C)	68°F (20°C)	70°F (21°C)	72°F (22°C)	75°F (24°C)
D-11—For Maximum Contrast	9	8	7	6 1/2	5 1/2
DK-50	2 1/2	2	2	1 3/4	1 3/4
DK-50 (1:1)	4 1/4	3 1/4	3 1/4	3	2 1/2
HC-110 (Dil B)	2 3/4	2 1/4	2 1/4	2	1 3/4
HC-110 (Dil D)	4 3/4	4 1/2	4 1/4	4	3 3/4

* With continuous agitation.

† With gaseous-burst agitation (1 second every 10 seconds) that provides pressure to raise the solution level 5/8 inch (16 mm). Development times shorter than 5 minutes may produce unsatisfactory uniformity.

Characteristic Curve

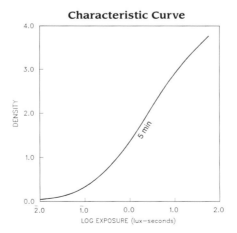

Process: Tray; KODAK PROFESSIONAL Developer DK-50, 68°F (20°C)

Contrast-Index Curves

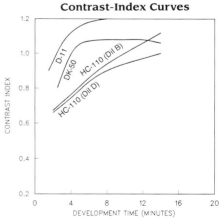

Process: Tray; 68°F (20°C)

KODAK PROFESSIONAL EKTAPAN Film / 4162

KODAK PROFESSIONAL EKTAPAN Film is a medium-speed panchromatic film that features very fine grain. It is well suited for portraiture and close-up work with electronic flash. It is also an excellent choice for commercial, industrial, and scientific applications with daylight or tungsten light. You can retouch this film on the base or the emulsion side.

Sizes Available:
70 mm long rolls
Sheets (on ESTAR Thick Base)

Emulsion Characteristics:

Spectral Sensitivity—Panchromatic

Grain—Very fine

Resolving Power—
Low-Contrast Test Object:
 50 lines/mm
High-Contrast Test Object:
 125 lines/mm (High)

Speed: ISO 100/21°

Filter Factors: Multiply the normal exposure by the filter factor indicated below.

KODAK PROFESSIONAL WRATTEN Gelatin Filter	No. 8	No. 11	No. 15	No. 25	No. 29	No. 47	No. 58	Polarizing Filter
Daylight or Electronic Flash	2	4	3	8	16	5	8	2.5
Tungsten	1.5	3	2	4	8	10	8	2.5

Darkroom Recommendations: Handle this film in total darkness. After development is half complete, you can use a KODAK PROFESSIONAL 3 Safelight Filter (dark green) in a suitable safelight lamp with a 15-watt bulb *for a few seconds only*. Keep the safelight at least 4 feet (1.2 metres) from the film.

Development: The development times in the table below are starting-point recommendations; the times in **bold type** are the primary recommendations (see page 52). To increase contrast, increase the development time; to decrease contrast, decrease the development time. (For more information, see "Contrast" on page 14.)

KODAK Developer or Developer and Replenisher	Development Time (Minutes)									
	Tray* or Large Tank†					Large Tank‡§				
	65°F (18°C)	68°F (20°C)	70°F (21°C)	72°F (22°C)	75°F (24°C)	65°F (18°C)	68°F (20°C)	70°F (21°C)	72°F (22°C)	75°F (24°C)
T-MAX RS	6	**5**	4	4	3	6	**5**	4	3½	3
HC-110 (Dil B)	5	**4½**	4¼	4	3½	7	**6**	5½	5	4¼
D-76	9	**8**	7	6½	5½	11	**10**	9	8½	7½
DK-50 (1:1)	5	**4½**	4¼	4	3½	7	**6**	5½	5	4¼
MICRODOL-X	12	**10**	9½	8	7	16	**13**	12	10	9
HC-110 (Dil A)	3¼	**3**	2¾	2½	2¼	4	**3¾**	3¼	3	2¾
XTOL (1:1)‖	—	9½	8½	—	6	9½	8	6¾	—	5½

* With continuous agitation.
† With gaseous-burst agitation (1 second every 10 seconds) that provides pressure to raise the solution level 5/8 inch (16 mm). Development times shorter than 5 minutes may produce unsatisfactory uniformity.
‡ With manual agitation at 1-minute intervals. Development times shorter than 5 minutes may produce unsatisfactory uniformity.
§ Use only KODAK PROFESSIONAL HC-110 Developer (Dilution B) to process long rolls on spiral reels, and add 1 minute to the times given in the table.

‖ The recommendations for using KODAK PROFESSIONAL XTOL Developer in a large tank are based on a nitrogen burst cycle of 2 seconds every 8 seconds. Significantly more (less) agitation may require slightly shorter (longer) development times. Development times shorter than 4 minutes may produce unsatisfactory uniformity.

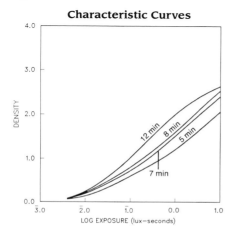

Characteristic Curves

Process: Large Tank; KODAK PROFESSIONAL HC-110 Developer (Dil B), 68°F (20°C)

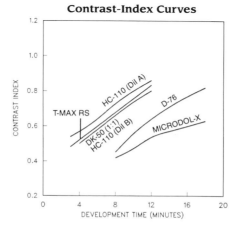

Contrast-Index Curves

Process: Tray: 68°F (20°C)

KODAK PLUS-X Pan Film / 5062
KODAK PLUS-X Pan Professional Film / 6057

KODAK PLUS-X Pan Film and KODAK PLUS-X Pan Professional Film are medium-speed panchromatic films that are good choices for general-purpose outdoor or studio photography. Their characteristic curve has a short toe and a long straight-line portion, which make them ideal for the high-flare conditions of many outdoor scenes. These films feature very good tone-reproduction characteristics. You can retouch PLUS-X Pan Professional Film on the emulsion side.

Sizes Available:
5062-135, 35 mm long rolls
6057-120, 220

Emulsion Characteristics:

Spectral Sensitivity—Panchromatic

Grain—Extremely fine

Resolving Power—
Low-Contrast Test Object:
 50 lines/mm
High-Contrast Test Object:
 125 lines/mm (High)

Speed: ISO 125/22°

Filter Factors: Multiply the normal exposure by the filter factor indicated below.

KODAK PROFESSIONAL WRATTEN Gelatin Filter	No. 8	No. 11	No. 15	No. 25	No. 47	No. 58	Polarizing Filter
Daylight or Electronic Flash	2	4	2.5	6	6	8	2.5
Tungsten	1.5	4	1.5	4	12	8	2.5

Development: The development times in the table below are starting-point recommendations; the times in **bold type** are the primary recommendations (see page 52). To increase contrast, increase the development time; to decrease contrast, decrease the development time. (For more information, see "Contrast" on page 14.)

Darkroom Recommendations:
Handle these films in total darkness. After development is half complete, you can use a KODAK PROFESSIONAL 3 Safelight Filter (dark green) in a suitable safelight lamp with a 15-watt bulb *for a few seconds only*. Keep the safelight at least 4 feet (1.2 metres) from the film.

KODAK Developer or Developer and Replenisher	Development Time (Minutes)									
	Small Tank*					Large Tank†‡§				
	65°F (18°C)	68°F (20°C)	70°F (21°C)	72°F (22°C)	75°F (24°C)	65°F (18°C)	68°F (20°C)	70°F (21°C)	72°F (22°C)	75°F (24°C)
T-MAX	6½	5½	5½	5	**5**	NR	NR	NR	NR	NR
T-MAX RS	6½	**5½**	4½	4	3½	9	8	7	6	5½
HC-110 (Dil B)	6	**5**	4½	4	3½	6½	**5½**	5	4¾	4
D-76	6½	**5½**	5	4½	3¾	7½	**6½**	6	5½	4½
D-76 (1:1)	8	7	6½	6	5	10	9	8	7½	7
MICRODOL-X	8	**7**	6½	6	5½	10	9	8	7½	7
MICRODOL-X (1:3)	NR	NR	11	10	**9½**	NR	NR	14	13	**11**
XTOL (5062)	6½	5¼	4¾	—	3¾	7½	6½	6	—	4
XTOL (6057)	6¾	5½	5	—	3¾	8½	6¾	6	—	4½

* With agitation at 30-second intervals. Development times shorter than 5 minutes may produce unsatisfactory uniformity.

† With manual agitation at 1-minute intervals. Development times shorter than 5 minutes may produce unsatisfactory uniformity.

‡ Use only KODAK PROFESSIONAL HC-110 Developer (Dilution B) to process long rolls on spiral reels; develop for 6 minutes at 68°F (20°C).

§ The recommendations for using KODAK PROFESSIONAL XTOL Developer in a large tank are based on a nitrogen burst cycle of 2 seconds every 8 seconds. Significantly more (less) agitation may require slightly shorter (longer) development times. Development times shorter than 4 minutes may produce unsatisfactory uniformity.
NR = Not Recommended

Characteristic Curves

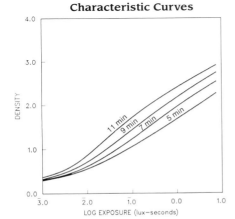

KODAK PLUS-X Pan Film / 5062
Process: Small Tank; KODAK T-MAX Developer, 75°F (24°C)

Contrast-Index Curves

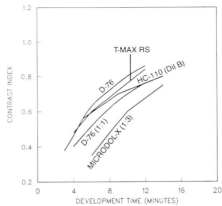

KODAK PLUS-X Pan Film / 5062
Process: Small Tank; 68°F (20°C) except KODAK PROFESSIONAL MICRODOL-X Developer (1:3) and KODAK T-MAX RS Developer and Replenisher, 75°F (24°C)

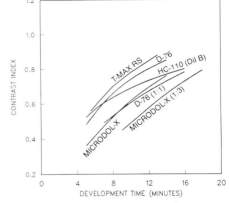

KODAK PLUS-X Pan Film / 6057
Process: Large Tank; 68°F (20°C) except KODAK PROFESSIONAL MICRODOL-X Developer (1:3) and KODAK T-MAX RS Developer and Replenisher, 75°F (24°C)

KODAK PLUS-X Pan Professional Film / 2147 and 4147

KODAK PLUS-X Pan Professional Film is a medium-speed panchromatic film with very fine grain and high resolving power. It has a long toe in the exposure range normally used. This makes it suitable for low-flare conditions and provides good separation of highlight tones. This film is an excellent choice for general studio photography. You can retouch the base or the emulsion side.

Sizes Available:
2147-70 mm long rolls
4147-Sheets (on ESTAR Thick Base)

Emulsion Characteristics:

Spectral Sensitivity—Panchromatic

Grain—Very fine

Resolving Power—
Low-Contrast Test Object:
50 lines/mm
High-Contrast Test Object:
125 lines/mm (High)

Speed: ISO 125/22°

Filter Factors: Multiply the normal exposure by the filter factor indicated below.

KODAK PROFESSIONAL WRATTEN Gelatin Filter	No. 8	No. 11	No. 15	No. 25	No. 29	No. 47	No. 58	Polarizing Filter
Daylight or Electronic Flash	2	4	2.5	6	25	6	8	2.5
Tungsten	1.5	4	1.5	4	12	12	8	2.5

Darkroom Recommendations: Handle this film in total darkness. After development is half complete, you can use a KODAK PROFESSIONAL 3 Safelight Filter (dark green) in a suitable safelight lamp with a 15-watt bulb *for a few seconds only.* Keep the safelight at least 4 feet (1.2 metres) from the film.

Development: The development times in the table below are starting-point recommendations; the times in **bold type** are the primary recommendations (see page 52). To increase contrast, increase the development time; to decrease contrast, decrease the development time. (For more information, see "Contrast" on page 14.)

KODAK Developer or Developer and Replenisher	Development Time (Minutes)									
	Tray* or Large Tank†					Large Tank‡				
	65°F (18°C)	68°F (20°C)	70°F (21°C)	72°F (22°C)	75°F (24°C)	65°F (18°C)	68°F (20°C)	70°F (21°C)	72°F (22°C)	75°F (24°C)
T-MAX RS	10	9	7 1/2	6 1/2	5	10	9	8	7 1/2	**7**
HC-110 (Dil B)	6	**5**	4 3/4	4 1/2	4	8	**7**	6 1/2	6	5 1/2
D-76	7	**6**	5 1/2	5	4 1/2	9	**8**	7 1/2	7	6
D-76 (1:1)	8	**7**	6 1/2	6	5	10	**9**	8	7 1/2	7
MICRODOL-X	9	**8**	7 1/2	7	6	11	**10**	9 1/2	9	8
DK-50 (1:1)	5	**4 1/2**	4 1/4	4	3 1/2	6 1/2	**6**	5 3/4	5 1/2	5
XTOL (tray)	7 1/2	6 1/4	5 3/4	—	4 1/2	—	—	—	—	—
XTOL (large tank)§	8 1/2	7 1/4	6 1/2	—	4 3/4	—	—	—	—	—

* With continuous agitation.
† With gaseous-burst agitation (1 second every 10 seconds) that provides pressure to raise the solution level 5/8 inch (16 mm). Development times shorter than 5 minutes may produce unsatisfactory uniformity.
‡ With manual agitation at 1-minute intervals.

§ The recommendations for using KODAK PROFESSIONAL XTOL Developer in a large tank are based on a nitrogen burst cycle of 2 seconds every 8 seconds. Significantly more (less) agitation may require slightly shorter (longer) development times. Development times shorter than 4 minutes may produce unsatisfactory uniformity.

Characteristic Curves

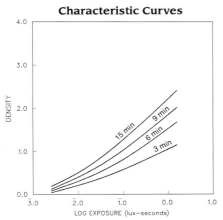

Process: Large Tank; KODAK PROFESSIONAL HC-110 Developer (Dil B), 68°F (20°C)

Contrast-Index Curves

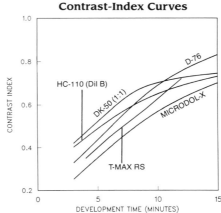

Process: Large Tank; 68°F (20°C)

KODAK PROFESSIONAL T-MAX Black-and-White Film T400 CN

KODAK PROFESSIONAL T-MAX Black-and-White Film T400 CN is a 400-speed, multipurpose film designed for processing in Process C-41 with other color negative films. The film can be printed on either black-and-white papers or color negative papers. It is intended for exposure with daylight, electronic flash, and artificial illumination. You can also obtain pleasing results under other light sources, i.e., illumination in stadiums, without using filters. You can use filters when exposing this film to vary the tone and contrast. Results are similar to conventional black-and-white films. This film incorporates KODAK T-GRAIN Emulsion technology, providing extremely fine grain and high sharpness with relatively high speed. It allows a very high degree of enlargement. You can use T400 CN for general, advertising, education, industrial, law enforcement, medical, newspaper, portrait, real estate, scientific, sports, wedding, and other black-and-white photographic applications.

Sizes Available: 135, 120

Exposure

Daylight: Use the exposures in the table at right for average front-lit subjects from 2 hours after sunrise to 2 hours before sunset.

Electronic Flash: Use the guide number from the table in the next column as a starting point for your equipment. Select the unit output closest to the number given by your flash manufacturer. Then find the guide number for feet or metres. To determine the lens opening, divide the guide number by the flash-to-subject distance. If negatives are consistently too dense (overexposed), use a higher guide number; if they are too thin (underexposed), use a lower number.

Adjustment for Long and Short Exposures: No exposure compensation for reciprocity failure is necessary for exposures between 1/10,000 second and 120 seconds. For critical applications, make tests under your conditions. Exposures longer than 120 seconds are not recommended.

Filter Factors: Multiply the normal exposure by the filter factor indicated below.

Unit Output (BCPS)*	Guide Number: in Feet	Guide Number: in Metres
350	85	26
500	100	30
700	120	36
1000	140	42
1400	170	50
2000	200	60
2800	240	70
4000	280	85
5600	340	105
8000	400	120

*BCPS = Beam Candlepower Seconds

KODAK PROFESSIONAL WRATTEN Gelatin Filter	No. 8	No. 11	No. 15	No. 25	No. 47	No. 58	Polarizing Filter
Daylight	1.4	3	2	8	12.5	5.6	2.5
Tungsten	1.25	3	1.4	3	16	4	2.5

Daylight Exposure		
Lighting Conditions	Shutter Speed	Lens Opening
Bright or hazy sun on light sand or snow	1/500	f/16
Bright or hazy sun (distinct shadows)	1/500	f/11*
Weak, hazy sun (soft shadows)	1/500	f/8
Cloudy bright (no shadows)	1/500	f/5.6
Heavy overcast or open shade†	1/500	f/4

* Use f/5.6 for backlit close-up subjects.
† Subject shaded from the sun but lit by a large area of clear sky.

Existing-Light Exposure		
Subject and Lighting Conditions	Shutter Speed	Lens Opening
Home interiors at night–average light	1/30	f/2
Home interiors at night–bright light	1/30	f/2.8
Aerial fireworks (Leave shutter open for several bursts)	"Bulb"/"Time"*	f/16
Interiors with bright fluorescent light	1/60†	f/4
Brightly lit street scenes at night	1/60	f/2.8
Neon and other lighted signs	1/125	f/2.8
Floodlighted buildings, fountains, monuments	1/15*	f/2
Night football, soccer, baseball, racetracks	1/125	f/2.8
Basketball, hockey, bowling	1/125	f/2
Stage shows–average light	1/60	f/2.8
Stage shows–bright light	1/250	f/2.8
Circuses and ice shows–floodlighted acts	1/125	f/2.8
Circuses and ice shows–spotlighted acts	1/250	f/2.8
School stages and auditoriums	1/30	f/2

* Use a tripod or other firm camera support for exposure times longer than 1/30 second.
† Use shutter speeds of 1/60 second or longer with fluorescent bulbs.

Darkroom Recommendations: Do not use a safelight. Handle unprocessed film in *total darkness*.

Processing: Process T400 CN Film in Process C-41. You can have this film processed by any photofinisher who processes color negative films. T400 CN can be intermixed with color negative films during processing in all equipment, from minilabs to high-volume continuous, roller transport, or rack-and-tank processors.

NOTE: Do not process this film in conventional black-and-white chemicals.

Push Processing: T400 CN can be rated at higher-than-normal exposure indexes for photography in dim light where fast shutter speeds must be maintained. Push processing in Process C-41 results in acceptable negatives from exposure indexes as high as 3200.

NOTE: Not all processing equipment can be used for push processing, and many photofinishers do not offer this service. Check with your lab or photofinisher before rating this film higher than EI 800.

Exposure Index	Approximate Developer Time (Minutes) in Process C-41
400 to 800	3:15 (normal)
1600	3:45
3200	4:15

Area Measured	Density Reading
The KODAK Gray Card (gray side) receiving the same illumination as the subject:	0.75 to 0.95
The lightest step (darkest in the negative) of a KODAK PROFESSIONAL Paper Gray Scale receiving the same illumination as the subject:	1.15 to 1.35
The lightest diffuse density of a normally lighted forehead: - light complexion: - dark complexion:	1.05 to 1.35 0.80 to 1.20

Negative Appearance: The appearance of processed negatives on T400 CN is similar to color negative films, but with no color in the negative images, and a much lower D-min or base density. The film base will appear very light brown. This is normal and will not affect image quality or printing characteristics, even when printing on black-and-white papers.

Judging Negative Exposures: You can check the exposure level with a suitable electronic densitometer equipped with a filter such as a KODAK PROFESSIONAL WRATTEN Gelatin Filter No. 92 or the red filter for Status M densitometry. Depending on the subject and the light source used for exposure, a normally exposed and processed color negative measured through the red filter should have the approximate densities as follows.

Because of the extreme range in skin color, use these red density values for a normally lighted forehead only as a guide. For most accurate results, use a KODAK Gray Card (gray side).

Storage and Handling: Load and unload your camera in subdued light. High temperatures or high humidity may produce unwanted quality changes. Store unexposed film at 70°F (21°C) or lower in the original package. Always store film (exposed or unexposed) in a cool, dry place. Though this film has excellent latent image-keeping characteristics (after exposure but before processing), for best results, process film as soon as possible after exposure.

Protect processed film from strong light, and store it in a cool, dry place. For more information on storing negatives, see KODAK Publication No. E-30, *Storage and Care of KODAK Photographic Materials—Before and After Processing*.

Characteristic Curve

Exposure: Daylight
Process: C-41
Densitometry: Status M
Log H Reference is -1.44

KODAK PROFESSIONAL Technical Pan Film / 2415, 4415, and 6415

KODAK PROFESSIONAL Technical Pan Film is Kodak's slowest and finest-grained black-and-white film for pictorial photography (when developed in KODAK PROFESSIONAL TECHNIDOL Liquid Developer). It is a variable-contrast panchromatic film with extended red sensitivity; because of its extended red sensitivity, it yields prints with a gray-tone rendering slightly different from that produced by other panchromatic films. (This is most noticeable in portraits, in which it suppresses blemishes.) Use this film for pictorial, scientific, technical, and reversal-processing applications. It is an excellent choice when you plan to make big enlargements or murals.

Sizes Available:
2415-135, 35 mm long rolls
4415-Sheets (on ESTAR Thick Base)
6415-120

Emulsion Characteristics:

Spectral Sensitivity—Panchromatic with extended red sensitivity

Grain—Micro fine
(based on development in KODAK PROFESSIONAL TECHNIDOL Liquid Developer)
Extremely fine (based on development in KODAK PROFESSIONAL HC-110 Developer [Dilution D])

Resolving Power—
Based on development in KODAK PROFESSIONAL HC-110 Developer (Dilution D)
Low-Contrast Test Object:
125 lines/mm
High-Contrast Test Object:
320 lines/mm (Extremely high)

Based on development in KODAK PROFESSIONAL TECHNIDOL Liquid Developer
Low-Contrast Test Object:
100 lines/mm
High-Contrast Test Object:
320 lines/mm (Extremely high)

Speed: The speed of the film depends on the application, the type and degree of development, and the level of contrast required. Therefore, no single speed value applies for all situations. Use the exposure indexes in the table below with meters marked for ISO, ASA, or DIN speeds or exposure indexes. They are intended for trial exposures.

You can expose this film with daylight or tungsten light. Exposure to tungsten illumination produces a 10-percent increase in speed and a 5-percent increase in contrast.

For pictorial applications, use EI 25/15° and process the film in KODAK PROFESSIONAL TECHNIDOL Liquid Developer.

For high-contrast reversal-processing applications, use EI 64/19° to produce slides from high-contrast subjects such as line art. Process the film with the KODAK T-MAX 100 Direct Positive Film Developing Outfit (see the instructions packaged with the outfit).

Darkroom Recommendations: Handle this film in total darkness. After development is half complete, you can use a KODAK PROFESSIONAL 3 Safelight Filter (dark green) in a suitable safelight lamp with a 15-watt bulb *for a few seconds only*. Keep the safelight at least 4 feet (1.2 metres) from the film.

Development: Use the developers listed in the table on page DS-8 to process Technical Pan Film to varying levels of contrast. Follow the instructions packaged with the film.

Contrast Index	KODAK PROFESSIONAL Developer	Development Time (Minutes) at 68°F (20°C)*	Exposure Index
High 2.50	DEKTOL	3	200
2.40 to 2.70	D-19 (1:2)	4 to 7	100 to 160
2.25 to 2.55	D-19	2 to 8	100 to 200
1.25 to 1.75	HC-110 (Dil D)	4 to 8	80 to 125
1.20 to 2.10	HC-110 (Dil B)	4 to 12	100 to 250
1.10 to 2.10	D-76	6 to 12	64 to 125
1.00 to 1.50	MICRODOL-X	8 to 12	32 to 50
0.80 to 0.95	HC-110 (Dil F)	6 to 12	32 to 64
Low 0.50 to 0.70	TECHNIDOL Liquid	5 to 11	16 to 25
0.60	XTOL (1:5)	12.5	25
0.60	XTOL (1:4)	10.5	12.5
0.60	XTOL (1:3)	8	8
0.60	XTOL (1:2)	6	4

*at 70°F (21°C) for KODAK PROFESSIONAL XTOL Developer

Filter Factors: Multiply the normal exposure by the filter factor indicated below.

KODAK PROFESSIONAL WRATTEN Gelatin Filter	No. 8	No. 11	No. 12	No. 15	No. 25	No. 47	No. 58
Daylight or Electronic Flash*	1.5	—	—	2	3	—	—
Tungsten†	1.2	5	1.2	1.2	2	25	12

* Based on a 1/25-second exposure and development in TECHNIDOL Liquid Developer for 9 minutes at 68°F (20°C).
†Based on a 1-second exposure and development in HC-110 Developer (Dilution D) for 8 minutes at 68°F (20°C).

Sheets

KODAK Developer or Developer and Replenisher	EI	Development Time (Minutes)									
		Tray*					Large Tank†‡				
		65°F (18°C)	68°F (20°C)	70°F (21°C)	72°F (22°C)	75°F (24°C)	65°F (18°C)	68°F (20°C)	70°F (21°C)	72°F (22°C)	75°F (24°C)
T-MAX RS	400	NR	8	7 1/2	7	**6**	NR	10	8	7 1/2	**6**
D-76	400	9 1/2	**7**	6 1/2	6	5 1/2	11	**10**	9	8	7
HC-110 (Dil B)	320	9	**7 1/2**	7	6 1/2	6	10	**8 1/2**	7 1/2	7	6 1/2
XTOL (1:1)	400	—	10 1/2	9 1/2	—	7 1/4	10	8 1/2	7 1/4	—	5 3/4

* With continuous agitation.
† With manual agitation at 1-minute intervals.
‡ The recommendations for using KODAK PROFESSIONAL XTOL Developer in a large tank are based on a nitrogen burst cycle of 2 seconds every 8 seconds. Significantly more (less) agitation may require slightly shorter (longer) development times. Development times shorter than 4 minutes may produce unsatisfactory uniformity.
NR = Not Recommended

Push Processing—Sheets

KODAK Developer and Replenisher	Development Time (Minutes)								
	Large Tank*†								
	EI 800 (NormalProcessing)				EI 1600 (2-Stop Push Processing)				EI 3200 (3-Stop Push Processing)
	68°F (20°C)	70°F (21°C)	72°F (22°C)	75°F (24°C)	68°F (20°C)	70°F (21°C)	72°F (22°C)	75°F (24°C)	75°F (24°C)
T-MAX RS	10	8	7 1/2	**6**	12	11	10	**9**	**12**
XTOL	9 1/2	8 1/4	—	6 1/2	11	9 3/4	—	7 3/4	8 3/4

* With manual agitation at 1-minute intervals.
† The recommendations for using KODAK PROFESSIONAL XTOL Developer in a large tank are based on a nitrogen burst cycle of 2 seconds every 8 seconds. Significantly more (less) agitation may require slightly shorter (longer) development times. Development times shorter than 4 minutes may produce unsatisfactory uniformity.

Characteristic Curves

Process: Small Tank; KODAK T-MAX Developer, 75°F (24°C)

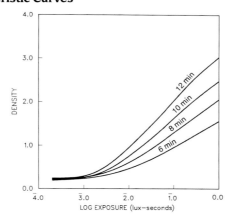

Process: Small Tank; KODAK PROFESSIONAL Developer D-76, 68°F (20°C)

Contrast-Index Curves

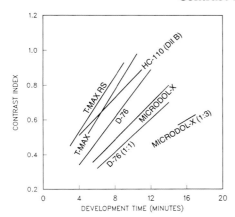

Process: Small Tank; 68°F (20°C) except KODAK T-MAX Developer, KODAK T-MAX RS Developer and Replenisher, and KODAK PROFESSIONAL MICRODOL-X Developer (1:3), 75°F (24°C)

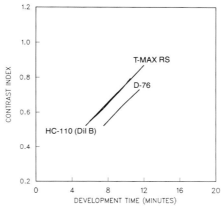

Process: Large Tank; 68°F (20°C) except KODAK T-MAX RS Developer and Replenisher, 75°F (24°C)

KODAK T-MAX P3200 Professional Film / 5054

KODAK T-MAX P3200 Professional Film is a multispeed panchromatic film that combines high to ultrahigh film speeds with finer grain than that of other fast black-and-white films. This film is especially useful for very fast action, for dimly lighted scenes where you can't use flash, for subjects that require good depth of field combined with fast shutter speeds, and for hand-holding telephoto lenses for fast action or in dim light. It is an excellent choice for indoor or night-time sports events and available-light press photography, as well as law-enforcement and general surveillance applications that require exposure indexes of 3200 to 25,000.

Note: This film is very sensitive to environmental radiation; expose and process it promptly. Request visual inspection of this film at airport x-ray inspection stations. Load and unload your camera in subdued light.

Size Available: 135

Emulsion Characteristics:
The data in this section are based on development at 68°F (20°C) in KODAK PROFESSIONAL Developer D-76.

Spectral Sensitivity—Panchromatic

Grain—Fine

Resolving Power—
Low-Contrast Test Object:
40 lines/mm
High-Contrast Test Object:
125 lines/mm (High)

Darkroom Recommendations:
Handle this film in total darkness. **Do not** develop this film by inspection. To avoid fogging this film, turn the face of fluorescent timers away from the area where you handle unprocessed film.

Speeds: This film is specially designed to be used as a *multispeed* film. The speed you use depends on your application; make tests to determine the appropriate speed. Set your camera or meter (marked for ISO, ASA, or DIN speeds or exposure indexes) at the speed given in the development tables for your developer.

The nominal speed is EI 1000 when the film is processed in KODAK T-MAX Developer or KODAK T-MAX RS Developer and Replenisher, or EI 800 when it is processed in other Kodak black-and-white developers. It was determined in a manner published in ISO standards. For ease in calculating exposure and for consistency with the commonly used scale of film-speed numbers, the nominal speed has been rounded to EI 800.

Because of its great latitude, you can expose this film at EI 1600 and yield negatives of high quality. There will be no change in the grain of the final print, but there may be a slight loss of shadow detail. When you need higher speed, you can expose this film at EI 3200 or 6400. At these speeds, there will be a slight increase in contrast and granularity with additional loss of shadow detail. (See the development tables for adjusted times.)

Because of the shape of the characteristic curve of this film, you will obtain better shadow detail and highlight separation when you expose it at EI 3200 or 6400 than you can obtain with 400-speed films pushed by 3 stops. These higher speeds allow you to take photographs in many situations where photography was previously impossible.

To expose this film at speeds higher than EI 6400, it is critical that you make tests to determine if results are appropriate for your needs. For best results when you expose this film at higher speeds, use T-MAX Developer or T-MAX RS Developer and Replenisher.

To expose film at speed settings that are higher than the maximum setting on your camera or meter, set the meter at a lower speed; then reduce the aperture or increase the shutter speed to compensate.

Note: Contrast and graininess will increase when you use higher exposure indexes.

Filter Factors: Multiply the normal exposure by the filter factor indicated below.

KODAK PROFESSIONAL WRATTEN Gelatin Filter	No. 8	No. 11	No. 12	No. 15	No. 25	No. 47	No. 58	Polarizing Filter
Daylight or Electronic Flash	1.5	3	1.5	1.5	6	9.5	6	2.5
Tungsten	1.2	3	1.2	1.5	4	19	6	2.5

Development: The development times in the following tables are starting-point recommendations. Make tests to determine the best development time for your application.

Small Tank*

KODAK Developer or Developer and Replenisher	Exposed at EI	Development Time (Minutes)					
		68°F (20°C)	70°F (21°C)	72°F (22°C)	75°F (24°C)	80°F (27°C)	85°F (29°C)
T-MAX	400	7 1/2	7	6 1/2	6	5	4
	800	8	7 1/2	7	6 1/2	5 1/2	4 1/2
	1600	8 1/2	8	7 1/2	7	6	5
	3200	11 1/2	11	10 1/2	9 1/2	8	6 1/2
	6400	14	13	12	11	9 1/2	8
	12,500†	16	15 1/2	14 1/2	12 1/2	10 1/2	9
	25,000†	NR	17 1/2	16	14	12	10
T-MAX RS	400	8	7	6 1/2	6	5 1/2	5
	800	9	8 1/2	7 1/2	6 1/2	6	5 1/2
	1600	10 1/2	9 1/2	8 1/2	7 1/2	7	6
	3200	13	12	11	10	9	8
	6400	15	14	13	11	10	9
	12,500†	18	16	14	12	11	10
	25,000†	NR	NR	16	14	13	11
D-76	400	10 1/2	9 1/2	8 1/2	7 1/2	6	4 1/2
	800	11	10	9	8	6 1/2	5
	1600	11 1/2	10 1/2	9 1/2	8 1/2	7	5 1/2
	3200	15	13 1/2	12 1/2	11	8 1/2	7 1/2
	6400	17 1/2	16	14 1/2	12 1/2	10 1/2	9
HC-110 (Dil B)	400	7 1/2	6 1/2	5 1/2	5	4 1/2	3 1/2
	800	8	7	6	5 1/2	4 3/4	4
	1600	9	7 1/2	6 1/2	6	5	4 1/2
	3200	11 1/2	10	8 1/2	7 1/2	6 1/2	5 3/4
	6400	14	12	10 1/2	9 1/2	8	6 3/4
XTOL	400	7 1/2	6 3/4	—	5 1/2	4 1/4	3 1/4
	800	8 1/4	7 1/2	—	6	4 3/4	3 3/4
	1600	9 1/4	8 1/2	—	7	5 1/4	4 1/4
	3200	11	10	—	8	6 1/4	4 3/4
	6400	12 1/2	11 1/2	—	9 1/4	7	5 1/2

* With agitation at 30-second intervals. Development times shorter than 5 minutes may produce unsatisfactory uniformity.
† Make tests to determine if results at these speeds are acceptable for your needs.
NR = Not Recommended

Large Tank*†

KODAK Developer and Replenisher	Exposed at EI	Development Time (Minutes)			
		68°F (20°C)	70°F (21°C)	72°F (22°C)	75°F (24°C)
T-MAX RS	400	10½	9½	8½	7½
	800	11½	10	9	8
	1600	13½	11½	10½	9½
	3200	17	14½	13	12
	6400	NR	18	16	14
	12,500‡	NR	NR	18	17
XTOL	400	9	8	—	6¼
	800	10	9	—	7
	1600	11	10	—	7¾
	3200	13	11½	—	9
	6400	15	13½	—	10½

* With manual agitation at 1-minute intervals.
† The recommendations for using KODAK PROFESSIONAL XTOL Developer in a large tank are based on a nitrogen burst cycle of 2 seconds every 8 seconds. Significantly more (less) agitation may require slightly shorter (longer) development times. Development times shorter than 4 minutes may produce unsatisfactory uniformity.
‡ Make tests to determine if results at this speed are acceptable for your needs.
NR = Not Recommended

Rotary-Tube Processors*

KODAK Developer or Developer and Replenisher	Exposed at EI	Development Time (Minutes)					
		68°F (20°C)	70°F (21°C)	72°F (22°C)	75°F (24°C)	80°F (27°C)	85°F (29°C)
T-MAX	400	6½	6	5½	4½	3½	3
	800	7½	6½	6	5	4	3½
	1600	8	7	6½	5½	4½	4
	3200	11	9½	8½	7½	6	5½
	6400	13	11½	10½	9	7½	6½
	12,500†	14½	13	12	10½	9	8
	25,000†	NR	15	14	12	11	10
T-MAX RS	400	9	8	7½	7	6½	4½
	800	10	9	8	7½	7	5
	1600	12	11	10	9½	9	5½
	3200	15	13	11½	10½	9½	7
	6400	16	14	12½	11½	10	8
	12,500†	NR	15	14	13	11½	9½
	25,000†	NR	16	15	14	12½	11
D-76	400	8	7½	7¼	6½	5	4
	800	8½	8	7¾	7	5½	4½
	1600	9	8½	8	7½	6	4¾
	3200	11½	11	10½	9½	7½	6
	6400	13½	13	12	11	8½	7
HC-110 (Dil B)	400	7	6¼	5¾	5	4¼	3¼
	800	8	7	6	5¼	4½	3½
	1600	8¾	7½	6½	5¾	4¾	3¾
	3200	11½	10	8½	7½	6½	5
	6400	13	11½	10	9	8	6
XTOL	400	7	6	—	5	—	—
	800	8	7	—	5½	—	—
	1600	9	8	—	6	—	—
	3200	10	9	—	7	—	—
	6400	11½	10	—	8	—	—

* Follow the agitation recommendations for your processor.
† Make tests to determine if results at these speeds are acceptable for your needs.
NR = Not Recommended

Characteristic Curves

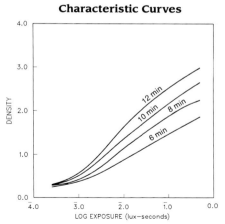

Process: Small Tank; KODAK T-MAX Developer, 75°F (24°C)

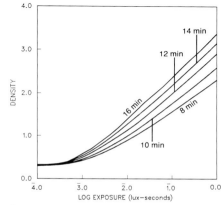

Process: Large Tank; KODAK T-MAX RS Developer and Replenisher, 75°F (24°C)

Contrast-Index Curves

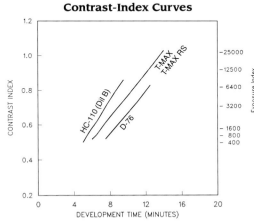

Process: Small Tank; 75°F (24°C)

KODAK TRI-X Pan Film / 5063 and 6043

KODAK TRI-X Pan Film is a high-speed panchromatic film that features fine grain, high sharpness, and high resolving power. It is especially useful for photographing dimly lighted subjects or fast action, for extending the distance range for flash pictures, and for photographing subjects that require good depth of field and fast shutter speeds. You can retouch this film in the 120 size on the emulsion side.

Push processing allows you to expose the film at higher film-speed numbers for conditions such as low-level light, stop-action, or existing light. However, there will be a loss of shadow detail and an increase in graininess.

Because of the film's exposure latitude, you can underexpose by one stop at EI 800 and use normal processing times. Prints will show a slight loss in shadow detail.

You can underexpose by two stops at EI 1600 if you increase development time by push processing. Prints will show an increase in contrast and graininess with additional loss of shadow detail. However, the results will be acceptable for many applications.

You can underexpose by three stops at EI 3200 if you increase development time by push processing. Prints will show an increase in contrast and graininess with further loss of shadow detail. However, the results will be acceptable for many applications. Expose a test roll to determine the film speed that will give the best results for your application.

Sizes Available:
5063-135, 35 mm and 70 mm long rolls (unperforated)
6043-120

Emulsion Characteristics:

Spectral Sensitivity—Panchromatic

Grain—Fine

Resolving Power—
Low-Contrast Test Object:
 50 lines/mm
High-Contrast Test Object:
 100 lines/mm (High)

Speed: ISO 400/27°

Filter Factors: Multiply the normal exposure by the filter factor indicated below.

KODAK PROFESSIONAL WRATTEN Gelatin Filter	No. 8	No. 11	No. 12	No. 15	No. 25	No. 47	No. 58	Polarizing Filter
Daylight or Electronic Flash	2	4	2.5	2.5	8	6	6	2.5
Tungsten	1.5	3	—	1.5	5	12	6	2.5

Darkroom Recommendations:
Handle this film in total darkness. After development is half complete, you can use a KODAK PROFESSIONAL 3 Safelight Filter (dark green) in a suitable safelight lamp with a 15-watt bulb *for a few seconds only*. Keep the safelight at least 4 feet (1.2 metres) from the film.

Development:
The development times in the table below are starting-point recommendations; the times in **bold type** are the primary recommendations (see page 52). To increase contrast, increase the development time; to decrease contrast, decrease the development time. (For more information, see "Contrast" on page 14.)

KODAK Developer or Developer and Replenisher	Development Time (Minutes)									
	Small Tank*					Large Tank†‡				
	65°F (18°C)	68°F (20°C)	70°F (21°C)	72°F (22°C)	75°F (24°C)	65°F (18°C)	68°F (20°C)	70°F (21°C)	72°F (22°C)	75°F (24°C)
T-MAX	7	6	6	5½	**5½**	NR	NR	NR	NR	NR
T-MAX RS	7	6	5½	5½	**5**	12	10	8½	7½	6½
HC-110 (Dil B)	8½	**7½**	6½	6	5	9½	**8½**	8	7½	6½
D-76	9	**8**	7½	6½	5½	10	**9**	8	7	6
D-76 (1:1)	11	**10**	9½	9	8	13	**12**	11	10	9
MICRODOL-X	11	**10**	9½	9	8	13	**12**	11	10	9
MICRODOL-X (1:3)	NR	NR	15	14	**13**	NR	NR	17	16	**15**
DK-50 (1:1)	7	**6**	5½	5	4½	7½	**6½**	6	5½	5
HC-110 (Dil A)	4¼	**3¾**	3¼	3	2½	4¾	**4¼**	4	3¾	3¼
XTOL (5063)	7¾	6¾	6	—	4¾	9½	8	7½	—	5½
XTOL (6043)	7½	6¼	5½	—	4¼	9	7½	6½	—	4¾

* With agitation at 30-second intervals. Development times shorter than 5 minutes may produce unsatisfactory uniformity.
† With manual agitation at 1-minute intervals. Development times shorter than 5 minutes may produce unsatisfactory uniformity.
‡ The recommendations for using KODAK PROFESSIONAL XTOL

Developer in a large tank are based on a nitrogen burst cycle of 2 seconds every 8 seconds. Significantly more (less) agitation may require slightly shorter (longer) development times. Development times shorter than 4 minutes may produce unsatisfactory uniformity.
NR = Not Recommended

Push Processing

KODAK Developer or Developer and Replenisher	Development Time (Minutes)									
	Large Tank*†									
	EI 1600 (2-Stop Push Process)					EI 3200 (3-Stop Push Process)				
	65°F (18°C)	68°F (20°C)	70°F (21°C)	72°F (22°C)	75°F (24°C)	65°F (18°C)	68°F (20°C)	70°F (21°C)	72°F (22°C)	75°F (24°C)
T-MAX	11½	10	9½	9	8½	NR	NR	NR	NR	11
T-MAX RS	—	9½	9	8½	8	NR	12	11½	11½	11
D-76	16	13	12	11	10	NR	NR	NR	NR	NR
HC-110 (Dil B)	18	16	15	13½	12	NR	NR	NR	NR	NR
XTOL (5063)	10½	9	8	—	6½	12½	10½	9½	—	7½
XTOL (6043)	10¼	8¾	7¾	—	6	12	10¼	9	—	7

* With agitation at 30-second intervals.
NR = Not Recommended

KODAK Developer or Developer and Replenisher	Development Time (Minutes)									
	Large Tank*†									
	EI 1600 (2-Stop Push Process)					EI 3200 (3-Stop Push Process)				
	65°F (18°C)	68°F (20°C)	70°F (21°C)	72°F (22°C)	75°F (24°C)	65°F (18°C)	68°F (20°C)	70°F (21°C)	72°F (22°C)	75°F (24°C)
T-MAX RS	—	14	12½	10½	9	—	—	—	—	13½
D-76	15	13	12	11	10	NR	NR	NR	NR	NR
HC-110 (Dil B)	18	16	15	13½	12	NR	NR	NR	NR	NR
XTOL (5063)	12½	10½	9½	—	7½	14½	12	11	—	8½
XTOL (6043)	12½	10½	9½	—	7	14½	12½	11	—	8¼

* With manual agitation at 1-minute intervals.
† The recommendations for using KODAK PROFESSIONAL XTOL Developer in a large tank are based on a nitrogen burst cycle of 2 seconds every 8 seconds. Significantly more (less) agitation may require slightly shorter (longer) development times.

NR = Not Recommended
Note: KODAK T-MAX Developer is not recommended for processing in large tanks.

Characteristic Curves

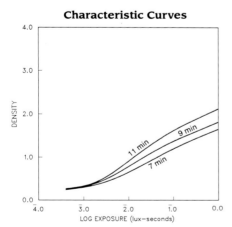

Process: Large Tank; KODAK PROFESSIONAL Developer D-76, 68°F (20°C)

Contrast-Index Curves

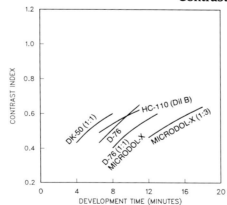

Process: Large Tank; 68°F (20°C) except KODAK PROFESSIONAL MICRODOL-X Developer (1:3), 75°F (24°C)

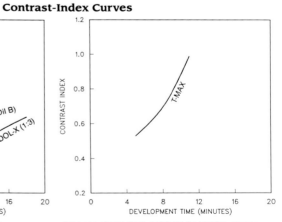

Process: Small Tank; KODAK T-MAX Developer, 75°F (24°C)

KODAK TRI-X Pan Professional Film / 6049

KODAK TRI-X Pan Professional Film is a high-speed panchromatic film that features excellent tone gradation and brilliant highlights. It is especially well suited to low-flare interior lighting or flash illumination. It is also useful for portraiture with low-contrast backlighting outdoors. You can retouch the base or the emulsion side.

Sizes Available: 120, 220

Emulsion Characteristics:

Spectral Sensitivity—Panchromatic

Grain—Fine

Resolving Power—
Low-Contrast Test Object:
32 lines/mm
High-Contrast Test Object:
100 lines/mm (High)

Speed: ISO 320/26°

Filter Factors: Multiply the normal exposure by the filter factor indicated below.

KODAK PROFESSIONAL WRATTEN Gelatin Filter	No. 8	No. 11	No. 12	No. 25	No. 47	No. 58	Polarizing Filter
Daylight or Electronic Flash	2	4	2.5	8	6	8	2.5
Tungsten	1.5	4	2	5	10	8	2.5

Darkroom Recommendations: Handle this film in total darkness. After development is half complete, you can use a KODAK PROFESSIONAL 3 Safelight Filter (dark green) in a suitable safelight lamp with a 15-watt bulb *for a few seconds only.* Keep the safelight at least 4 feet (1.2 metres) from the film.

Development: The development times in the table below are starting-point recommendations; the times in **bold type** are the primary recommendations (see page 52). To increase contrast, increase the development time; to decrease contrast, decrease the development time. (For more information, see "Contrast" on page 14.)

KODAK Developer or Developer and Replenisher	Development Time (Minutes)									
	Small Tank*					Large Tank†‡				
	65°F (18°C)	68°F (20°C)	70°F (21°C)	72°F (22°C)	75°F (24°C)	65°F (18°C)	68°F (20°C)	70°F (21°C)	72°F (22°C)	75°F (24°C)
T-MAX	9	8	7 1/2	7	**6 1/2**	NR	NR	NR	NR	NR
T-MAX RS	5	**4**	3 1/2	3 1/2	3	7	6	5 1/2	5 1/2	5
D-76	9	8	7 1/2	7	6	10	9	8 1/2	8	7
DK-50 (1:1)	9	8	7 1/2	7	6	10	9	8 1/2	8	7
HC-110 (Dil B)	5 3/4	**5 1/2**	5 1/4	4 3/4	3 3/4	7	**6 1/4**	6	5 1/2	5
MICRODOL-X	11	**10**	9	8 1/2	7 1/2	12	**11**	10	9	8
HC-110 (Dil A)	NR	NR	NR	NR	NR	3 1/2	**3**	3	2 3/4	2 1/4
XTOL	7 1/2	6 1/4	5 1/2	—	4 1/2	9 1/2	7 1/2	6 1/2	—	5 1/4

* With agitation at 30-second intervals. Development times shorter than 5 minutes may produce unsatisfactory uniformity.

† With agitation at 1-minute intervals. Development times shorter than 5 minutes may produce unsatisfactory uniformity.

‡ The recommendations for using KODAK PROFESSIONAL XTOL Developer in a large tank are based on a nitrogen burst cycle of 2 seconds every 8 seconds. Significantly more (less) agitation may require slightly shorter (longer) development times. Development times shorter than 4 minutes may produce unsatisfactory uniformity.

NR = Not Recommended

Characteristic Curves

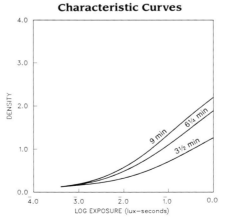

Process: Large Tank; KODAK PROFESSIONAL HC-110 Developer (Dil B), 68°F (20°C)

Contrast-Index Curves

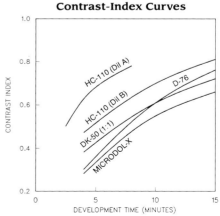

Process: Large Tank; 68°F (20°C)

KODAK TRI-X Pan Professional Film / 4164

KODAK TRI-X Pan Professional Film is a high-speed panchromatic film that has sensitometric characteristics similar to those of KODAK TRI-X Pan Professional Film / 6049. You can retouch the base or the emulsion side.

Size Available:
Sheets (on ESTAR Thick Base)

Emulsion Characteristics:

Spectral Sensitivity—Panchromatic

Grain—Fine

Resolving Power—
Low-Contrast Test Object:
 32 lines/mm
High-Contrast Test Object:
 100 lines/mm (High)

Speed: ISO 320/26°

Filter Factors: Multiply the normal exposure by the filter factor indicated below.

KODAK PROFESSIONAL WRATTEN Gelatin Filter	No. 8	No. 11	No. 15	No. 25	No. 47	No. 58	Polarizing Filter
Daylight or Electronic Flash	2	4	2.5	8	6	8	2.5
Tungsten	1.5	4	2	5	10	8	2.5

Darkroom Recommendations: Handle this film in total darkness. After development is half complete, you can use a KODAK PROFESSIONAL 3 Safelight Filter (dark green) in a suitable safelight lamp with a 15-watt bulb *for a few seconds only*. Keep the safelight at least 4 feet (1.2 metres) from the film.

Development: The development times in the table below are starting-point recommendations; the times in **bold type** are the primary recommendations (see page 52). To increase contrast, increase the development time; to decrease contrast, decrease the development time. (For more information, see "Contrast" on page 14.)

KODAK Developer or Developer and Replenisher	Development Time (Minutes)									
	Tray* or Large Tank†					Large Tank‡§				
	65°F (18°C)	68°F (20°C)	70°F (21°C)	72°F (22°C)	75°F (24°C)	65°F (18°C)	68°F (20°C)	70°F (21°C)	72°F (22°C)	75°F (24°C)
T-MAX RS	6	**5**	4	NR	NR	5½	**5**	4½	4½	4
HC-110 (Dil B)	6	**5½**	5	4½	4	8	**7½**	7	6	5
D-76	6	**5½**	5	5	4½	7½	**7**	6½	6	5½
MICRODOL-X	8	**7**	6	5½	5	10	**9**	8	7½	6½
DK-50 (1:1)	5	**5**	4½	4½	4	7	**6½**	6	5½	5
XTOL (1:1) (tray)	—	9	8	—	6	—	—	—	—	—
XTOL	—	—	—	—	—	8½	7	6	—	4¾

* With continuous agitation.
† With gaseous-burst agitation (1 second every 10 seconds) that provides pressure to raise the solution level 5/8 inch (16 mm). Development times shorter than 5 minutes may produce unsatisfactory uniformity.
‡ With manual agitation at 1-minute intervals. Development times shorter than 5 minutes may produce unsatisfactory uniformity.

§ The recommendations for using KODAK PROFESSIONAL XTOL Developer in a large tank are based on a nitrogen burst cycle of 2 seconds every 8 seconds. Significantly more (less) agitation may require slightly shorter (longer) development times. Development times shorter than 4 minutes may produce unsatisfactory uniformity.
NR = Not Recommended

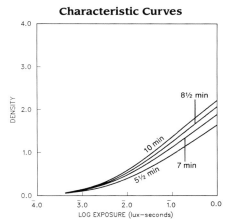

Characteristic Curves

Process: Large Tank; KODAK PROFESSIONAL HC-110 Developer (Dil B), 70°F (21°C)

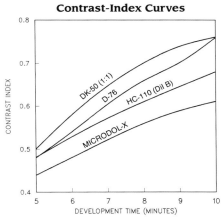

Contrast-Index Curves

Process: Large Tank; 70°F (21°C)

KODAK VERICHROME Pan Film / 6041

KODAK VERICHROME Pan Film is a medium-speed panchromatic film that features extremely fine grain. Its excellent gradation and wide exposure latitude make it a good choice for general-purpose applications.

Size Available: 120

Emulsion Characteristics:

Spectral Sensitivity—Panchromatic

Grain—Extremely fine

Resolving Power—
Low-Contrast Test Object:
 50 lines/mm
High-Contrast Test Object:
 100 lines/mm (High)

Speed: ISO 125/22°

Filter Factors: Multiply the normal exposure by the filter factor indicated below.

KODAK PROFESSIONAL WRATTEN Gelatin Filter	No. 8	No. 11	No. 15	No. 25	No. 47	No. 58	Polarizing Filter
Daylight or Electronic Flash	2	4	2.5	8	6	6	2.5
Tungsten	1.5	4	1.5	5	12	6	2.5

Darkroom Recommendations: Handle this film in total darkness. After development is half complete, you can use a KODAK PROFESSIONAL 3 Safelight Filter (dark green) in a suitable safelight lamp with a 15-watt bulb *for a few seconds only*. Keep the safelight at least 4 feet (1.2 metres) from the film.

Development: The development times in the table below are starting-point recommendations; the times in **bold type** are the primary recommendations (see page 52). To increase contrast, increase the development time; to decrease contrast, decrease the development time. (For more information, see "Contrast" on page 14.)

KODAK Developer or Developer and Replenisher	Development Time (Minutes)									
	Small Tank*					Large Tank†‡				
	65°F (18°C)	68°F (20°C)	70°F (21°C)	72°F (22°C)	75°F (24°C)	65°F (18°C)	68°F (20°C)	70°F (21°C)	72°F (22°C)	75°F (24°C)
T-MAX	—	**6**	5½	5	4	—	—	—	—	—
T-MAX RS	—	**4**	4	3½	3½	—	**5½**	5	5	4
D-76	8	**7**	5½	5	4½	9	**8**	7	6	5
D-76 (1:1)	11	**9**	8	7	6	12½	**10**	9	8	7
HC-110 (Dil B)	6	**5**	4½	4	2	8	**6½**	6	5½	4½
MICRODOL-X	10	**9**	8	7	6	11	**10**	9	8	7
MICRODOL-X (1:3)	15	14	13	12	**11**	20	15	14	13	**12**
XTOL	7½	6	5¼	—	4	8½	7	6	—	4½

* With agitation at 30-second intervals. Development times shorter than 5 minutes may produce unsatisfactory uniformity.

† With agitation at 1-minute intervals. Development times shorter than 5 minutes may produce unsatisfactory uniformity.

‡ The recommendations for using KODAK PROFESSIONAL XTOL Developer in a large tank are based on a nitrogen burst cycle of 2 seconds every 8 seconds. Significantly more (less) agitation may require slightly shorter (longer) development times. Development times shorter than 4 minutes may produce unsatisfactory uniformity.

Characteristic Curves

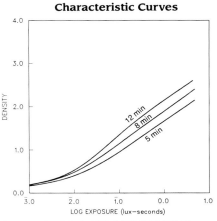

Process: Small Tank; KODAK PROFESSIONAL HC-110 Developer (Dil B), 68°F (20°C)

Contrast-Index Curves

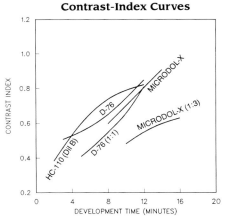

Process: Small Tank; 68°F (20°C)

KODAK PROFESSIONAL Copy Film / 4125

KODAK PROFESSIONAL Copy Film is an orthochromatic film designed for copying continuous-tone originals. You control the highlight contrast of this film by varying exposure and development.

Size Available:
Sheets (on ESTAR Thick Base)

Emulsion Characteristics:

Spectral Sensitivity—Orthochromatic

Grain—Fine

Resolving Power—
Low-Contrast Test Object:
 40 lines/mm
High-Contrast Test Object:
 80 lines/mm (Medium)

Darkroom Recommendations: Use a KODAK PROFESSIONAL 2 Safelight Filter (dark red) in a suitable safelight lamp with a 15-watt bulb. Keep the safelight at least 4 feet (1.2 metres) from the film. You can use a KODAK PROFESSIONAL 1 Safelight Filter (red) for a short time.

Speeds:
Tungsten—ISO 12/12°
Pulsed-Xenon Arc—ISO 25/15°

Use the setting for tungsten illumination with meters marked for ISO, ASA, or DIN speeds or exposure indexes for trial exposures. It applies to incident-light meters directly and to reflected-light meter readings of a KODAK Gray Card at the copyboard. If you use a matte-white card, multiply the calculated exposure time by 5.

The pulsed-xenon-arc value indicates the speed of this film to pulsed-xenon illumination measured with a light integrator.

Development: The development times in the table below are starting-point recommendations. The optimum development time depends on the type of original (continuous-tone, line copy, or a combination of both); the surface, contrast, and tint of the original; the subject matter; camera lens flare; type of enlarger light system (specular or diffuse); the paper you print on; the enlarger or copyboard illumination (tungsten light produces slightly higher contrast than pulsed-xenon light); or a combination of these variables.

Light Source	KODAK PROFESSIONAL Developer	Development Time (Minutes) at 68°F (20°C)	
		Tray*	Large Tank†
Tungsten	HC-110 (Dil E)	4	5
	DK-50 (1:1)	3 to 3½	3½
Pulsed-Xenon	HC-110 (Dil E)	4	5
	DK-50 (1:1)	3	3½

* With continuous agitation.
† With manual agitation at 1-minute intervals.

Characteristic Curves

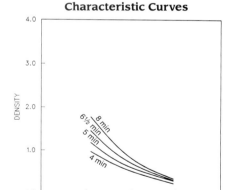

Process: Large Tank; KODAK PROFESSIONAL HC-110 Developer (Dil E)

KODAK PROFESSIONAL B/W Duplicating Film SO-132

KODAK PROFESSIONAL B/W Duplicating Film SO-132 is an orthochromatic direct-positive film designed for one-step duplication of continuous-tone black-and-white negatives. This film does not require reversal processing. It features a long tonal range for high-quality duplicates. For long-term keeping, you can treat this film with KODAK PROFESSIONAL Rapid Selenium Toner or KODAK PROFESSIONAL Brown Toner.

Size Available:
Sheets (on ESTAR Thick Base)

Darkroom Recommendations: Use a KODAK PROFESSIONAL 1A Safelight Filter (light red) in a suitable safelight lamp with a 15-watt bulb. Keep the safelight at least 4 feet (1.2 metres) from the film.

Emulsion Characteristics:

Spectral Sensitivity—Orthochromatic

Grain—Very fine

Exposure: You can use tungsten, fluorescent, or tungsten-halogen light sources to expose this film. Make a series of test exposures under your conditions. Start with a trial exposure of 40 seconds if you use a tungsten light source that provides 5 footcandles (53 lux) at the exposure plane. More exposure produces lower densities in the duplicate; less exposure produces higher densities.

Note: With some developers, this film will require 2/3 to 1 stop more exposure than with KODAK Professional B/W Duplicating Film SO-339.

Development: The development times in the table below are starting-point recommendations; you can vary the development time to produce the required contrast in the duplicate.

KODAK PROFESSIONAL Developer	Development Time (Minutes) at 68°F (20°C)	
	Tray*	Tank†
DEKTOL (1:1)	2	NR
DK-50	4 to 6	4 to 6
D-76 (1:1)	10	10
XTOL	5	5
XTOL (1:2)‡	12	NR

* With continuous agitation. Development times shorter than 5 minutes may produce unsatisfactory uniformity.
† With agitation at 1-minute intervals. Development times shorter than 5 minutes may produce unsatisfactory uniformity.
‡ Allows more contrast adjustment with development time change.
NR = Not Recommended

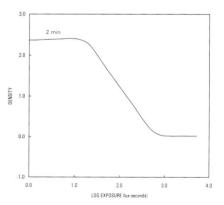

Characteristic Curve

Process: Tray; KODAK PROFESSIONAL XTOL Developer (1:2), 68°F (20°C), Agitation at 30 second intervals

Characteristic Curve

Process: Tray; KODAK PROFESSIONAL DEKTOL Developer (1:1), 68°F (20°C), Continuous Agitation

Index